TWO SCHOOLS *of* THOUGHT

TWO
SCHOOLS
of
THOUGHT

Some Tales of
Learning and Romance

CAROLYN SEE & JOHN ESPEY

JOHN DANIEL & COMPANY, PUBLISHERS
SANTA BARBARA · 1991

"Lo, The Rhodes Scholar!" first appeared in slightly different form in *impromptu,* an occasional publication of Occidental College. In connection with the chapter titled "The Long Christmas Dinner Society," the author is not surprised to find that his surviving classmates hold a variety of views concerning the precise distance between the unfortunate Exhibitioner's grandfather and the grave; but he has no doubt that his own memory clearly records what must be considered the ultimate version. Most of the quoted conversations are taken from personal letters written at the time, but even Mertonians cannot have spoken so consistently in complete periods.

Design and typography by Jim Cook
Cover by Francine Rudesill

Published by John Daniel & Company, Publishers, a division of Daniel & Daniel, Publishers, Inc., Post Office Box 21922, Santa Barbara, California 93121. John Daniel & Company books are distributed to the trade by National Book Network, 4720 Boston Way, Lanham, Maryland 20706.

LIBRARY OF CONGRESS CATALOGING IN PUBLICATION DATA
See, Carolyn.
 Two schools of thought: some tales of learning and romance
/ Carolyn See and John Espey.
 p. cm.
 ISBN 0-936784-88-1
 1. English philology—Study and teaching (Higher)—
History—20th century. 2. Authors, American—20th century—
Biography. 3. See, Carolyn—Knowledge and learning.
4. Espey, John Jenkins, 1913- —Knowledge and learning.
5. University of California, Los Angeles. 6. University of
Oxford—History—20th century. I. Espey, John Jenkins, 1913-
. II. Title.
PE66.S44 1990 90-46324
820'.71'1—dc20 CIP

Each to the Other

Two Schools *of* Thought

Foreword

JOHN ESPEY AND CAROLYN SEE HAVE SO LIT-
tle in common it's a phenomenon. They are not from the same
social class, the same region, the same religion, or even the
same generation. But the unlikely, exhilarating truth is that
some years ago they pooled their resources and joined forces.
This book tells how they did it.

A bit more precisely, it tells how—beginning, literally, on
opposite sides of the world—they became the kind of people
who *could* do it. A book about learning in several senses, their
double memoir may be enjoyed as a hilarious collection of
tales told out of school, but it may also be read as a lesson in
how, with a little luck, book learning may be made to yield to a
kind of learning that no book can teach.

Educational reminiscence, so to call it, does not have an
especially proud record. At the low end, one finds the chummy
tedium of alumni magazines. At the high end (a low high)
stand works like Gilbert Highet's *The Art of Teaching*.

In that insufferably affable opusculum, Highet sets out to
honor great teachers. Unfortunately, the teachers he honors
most are the ones who taught the young Highet. Ostensibly, he
is beaming a smile of grateful admiration upward at them.
Actually, from their blessed company, he is beaming another

kind of smile downward at you. And you're not smiling back, not after you catch on.

John Espey, remembering his experiences as a Rhodes Scholar at Oxford, and Carolyn See, remembering hers as a graduate student at UCLA, do not beam with grateful admiration. Rather do they laugh aloud, each in a different tone, at folly in learned places. And unless, perchance, you were an Oxford don in the 1930s or a UCLA dean in the 1960s, you find yourself laughing along with them.

Alumni magazines and Gilbert Highet tell funny stories too, to be sure: charming, harmless little stories. What makes the stories in this book different from those is, first, that they are much funnier and, second, that they are not entirely harmless. Espey and See may forgive. They do not dote.

"Lo, The Rhodes Scholar!"

Espey presents Oxford dozing contentedly in the last decade before the fall of the Empire. The world has already changed around Great Britain, and the young, tri-continental visitor—of Chinese and European as well as American education—has seen a good deal more of it than his teachers have. They never quite notice this about him, however, and thereon hangs much of the hilarity.

The most richly satisfying dramatic situations are those in which the audience and one of the characters know what some central character has yet to find out. The tragic version of this can rise to the heights of *Othello* or *Oedipus Rex*. The comic version can be as simple as *Punch and Judy,* Punch not noticing the club in Judy's hands even while the children in the audience squeal their warning.

In Espey's chapter, we find ourselves in an agreeable middle range as the protagonist, a scholar effectively disguised as an American, moves about among the unsuspecting Oxonians. The local style is one of devastating repartee, the air ever alive with arrows. But arrow after arrow directed at Espey seems to end somehow, comically, stuck in an Oxford archer's foot.

Espey sends nothing whizzing back. Typically, the archer himself (on one memorable occasion, the archer is C.S. Lewis) imagines that he has scored quite a hit, and Espey lets him: It is not the quarry's place to instruct the hunter. But the laugh, suppressed then, is released now, fifty years later. And the laugh is, for that matter, only secondarily on Oxford or Imperial Britannia or on that pinched personage since raised aloft by the Campus Crusade for Christ. Primarily, it is on teachers anywhere who conclude on too little evidence that their knowledge of the world vastly exceeds that of their students.

"The In-Crowd"

The romance of the subtitle of this book appears mostly in its second chapter, Carolyn See's chapter. In See's fiction and, more remarkably, also in her criticism, a tone is occasionally struck that scarcely has its equal anywhere in current American writing. My private name for this tone is "High See," and I invariably welcome it even as, just as invariably, it unsettles me. High See is the sound of high intelligence joined to a reckless, a divine, an invincible lack of discretion. In telling the story of "The In-Crowd," her name for a group of her UCLA graduate school classmates, High See has rarely soared higher.

Oxford in the mid-1930s had the time to cultivate repartee because so much else—class, religion, occupation, income, domicile, and the place of one's nation in the world—were not seriously in question. And this stability was reinforced by the fact that many of the dons were celibate, if not exactly chaste. At UCLA in the early 1960s, by contrast, one's first acquaintance with the Metaphysical Poets coincided, as often as not, with one's first glimpse of a social world above the lower working class, with one's first marriage (or first divorce), with one's first bruising by the who-invited-you? demeanor of every American occupation toward its postulants, and with, not least, the impending collapse of America's post-War confidence about its unique place in the world.

Espey's Oxford, if hardly eternal, was at least old. At See's

UCLA, by contrast, many of the older faculty in the 1950s and 1960s were older than the university itself. The students were trying to break in at a university that was itself trying to break in. The result was a highly competitive situation in which everyone was trying desperately to measure up, but measure up *to what?* No one quite knew.

The further result, given the vague presence of older, more confident, more aristocratic universities in the background, was a hilarious double bind in which the student (the professor, too, for that matter) was enjoined simultaneously to moil like a peasant and to languish like a lord. The centuries of English literature were divided and sold off like mineral rights on so many parcels of desert; and when you got your deed, baby, it was time to drill. And yet, keep those fingernails clean! Those who would really strike it rich in the American academy were those who could successfully bring off the illusion that they had grown up on a country estate trading quips about Browning with the rector. Ah, Democracy!

Carolyn See supported her progress through this sport of institutional learning by managing a slum hotel with her first husband. Each morning, he and she would drive from downtown Los Angeles across town to the UCLA campus on the West Side. Each afternoon, like academic monks home from the fields, they would repair, exhausted, to their squalid monastery. Starved of all pleasure, that marriage broke up. Another succeeded it. That one too came to an end.

What lasted? What lasted was the in-crowd of See's title. Friendship, the least structured, the least formal of relationships, can be, in America, the only durable one. Her marriages, unsupported by any substructure of family, class, or religion, were held up, briefly, by the jerry-built, not-quite-there-yet subculture of the campus. When the marriages went, when the promise of the university was broken, what remained—the refuge and reviewing stand from which See now looks down, and back, on the several circus rings of her own life—was her friendship with the other members of the in-crowd.

The best seats on that reviewing stand are, of course, the ones

Foreword

where she and Espey sit side by side. (He shares the UCLA experience with her, though he does not write about it here.) The tacit, final chapter of this joint memoir is a picture of the two of them, two friends, talking to each other and turning their earlier lives, by the listening, into a comedy with this very conversation as its happy ending.

A happy ending! It could only happen in real life. Let Oxford snub. Let Westwood fumble. As they say on the Left Bank of the Los Angeles River, *Más enseña la vida que la universidad!*

<div align="right">

JACK MILES
Book Editor,
Los Angeles Times

</div>

John Espey, B.Litt.
(OXON. 1939)

Lo, The Rhodes Scholar!

MY FIRST GLIMPSE OF OXFORD MAY NOT have been the sort of experience that would lead most persons to apply for a Rhodes Scholarship, but in some ways it set the tone for much that I was to undergo when I returned five years later bearing the label—(CA and Merton '35)—that identifies me annually in "The American Oxonian" address list. I had been touring Europe in the summer of 1930 with my parents, following my graduation from the Shanghai American School, and late in August after a week of London sightseeing my mother and I, both somewhat sentimental Anglophiles, persuaded my father, a mild Anglophobe, that what we needed to round out our English travels was a day in Oxford. Father yielded grudgingly, and the three of us set out for Oxford one morning by bus. We took the bus because it was recommended to us by our travel agency on the grounds that we would "see more of the countryside" traveling this way.

The weather was fine, London then being in the grip of what the papers called a heat wave, and Mother and I exclaimed from time to time over the "intimacy" of the Berkshire scene while Father muttered about its "smallness."

In Oxford itself, Father bought a paper-bound guide book at a stationer's, and following one of its suggestions, "for those spending a few hours in Oxford," we set out down St. Aldate's

from Carfax, glanced briefly at Tom Tower, entered Christ Church, and headed for the Christ Church kitchens. A few moments on the way given to the fan-vaulting and an exit through Peckwater Quad took care of that particular college. We looked in through the gate of Oriel, then turned down into Merton Street, looked into Corpus Christi, and continued down Merton Street to the Merton lodge. Perhaps I should say in excusing us from not penetrating very far into Merton that in 1930 the front quadrangle was more than a little bleak, confronting one with the college Hall, not one of Merton's ornaments, and some of the buildings were still covered with a layer of dull cement work intended to look like cut stone. We went on down Merton Street, into the High, and then turned into Rose Lane and walked to the Meadows. When we returned to the High we dutifully admired Magdalen Tower.

During our tour Father had made remarks on the dinginess of the buildings, the inadequate heating and lighting of the few rooms we saw, and the general air of "Englishness" about the whole place, which he obviously found depressing. I think it may have been largely adolescent defiance that led me to declare at some point, "You know, this is the sort of place I'd like to study in."

"Wouldn't it be delightful?" Mother said.

And that was as far as that line advanced. Father's snort made clear that whatever funds had been earmarked for my higher education would not be squandered at this outrageously antiquated place.

But the three of us did agree that we were hungry, so we walked back to Carfax and turned up into Cornmarket Street. We had not gone far when Father brightened and, saying "I'll be right back," took off in a surprising burst of speed. Mother and I loitered along, looking at a restaurant across the street. Its diamond-paned windows and general air impressed us as belonging to just the sort of place one should lunch at in Oxford.

Father came back in a few moments, his face radiant. "Guess what there is up ahead!" he exclaimed. "A Woolworth's, a real Woolworth's! And there's a sandwich counter in the back."

Mother and I said nothing.

"It's even got the regular red-and-gold front," Father continued, "and though I don't suppose the sandwiches will amount to much, they're worth a try."

"Well, I don't know," Mother said with faint desperation. "A Woolworth's in Oxford!" She turned to me. "Do you want to try it?"

"No," I said, "I don't."

Father looked surprised.

"I think we ought to go to a good English restaurant," I said.

"Well, yes, a *good* English restaurant," Father remarked.

"Like that place over there," I said.

Father looked and said, "Oh dear!"

"I suppose we could split up for lunch," Mother suggested. "Really, a Woolworth's is all right, but somehow in *Oxford* . . ."

"Exactly," I said.

Father refused to give up Woolworth's. Mother and I crossed the street and entered our restaurant. We spoke with affectionate pity of Father's failure to appreciate what the situation required, and once we were seated we felt certain that we had made the correct choice. We sat at a table on the mezzanine from which we could look down on the main floor of the restaurant, and we ordered what we felt would be a typically English luncheon.

I am surprised that I have forgotten what this luncheon included, because we certainly waited long enough for it; so long, in fact, not only for the service to begin but also between courses, that Father had time to finish his Woolworth meal, which he found very tasty, and then make us four or five successive visits to find out how we were getting on. We were not getting on at all well. The food was soggy and tepid, the service sloppy, but we stuck it out and tried to give no sign that the entire meal was a fiasco.

Father, meanwhile, found his opinion of Oxford rising. Each new foray into the business section revealed to him that

~...ord was really a city, that it had some "almost adequate" department stores and a number of movie houses. "And from certain points," he said, "you don't really notice the colleges at all."

Somewhat dispirited, Mother and I took up our sightseeing again, going down Broad Street, looking in at Balliol and Trinity and continuing to the Sheldonian Theatre, the old Clarendon Building, and the Bodleian. By this time we realized that our bus would soon be leaving, so we went back to the terminal and returned to London.

I suppose it was the memory of "the real Oxford" that Mother and I always insisted we had somehow discovered that day that kept alive in me the notion that I should round out my education at Oxford, and during the four years of my undergraduate life at Occidental College in Los Angeles I was aware of a dim ambition stirring me to do something about it.

Actually, I did very little until the end of my junior year, when I took the trouble to find out just what was expected of a Rhodes Scholar. What I discovered discouraged me and for some time I saw my next three or four years following graduation as centering in Harvard or Yale—if necessary, even Princeton. What discouraged me was the disparity between myself and the ideal set up by the Rhodes Trustees; for when Cecil John Rhodes made his will he specified certain qualities that he expected his scholars to show. As listed in the announcement of the scholarships, they were

a) Literary and scholastic ability and attainments.
b) Qualities of manhood, truth, courage, devotion to duty, sympathy, kindliness, unselfishness, and fellowship.
c) Exhibition of moral force of character and of instincts to lead and to take an interest in his fellows.
d) Physical vigor, as shown by fondness for and success in sports.

I did not pull out of my depression until it occurred to me that I knew of no one who fitted all, or even very many, of these

godlike requirements, and when I looked up the records some Rhodes Scholars they seemed to reveal quite human limitations.

During the first semester of my senior year I applied formally to the college Rhodes Selection Committee as a candidate for their nomination. I learned that four others had also applied, none of whom struck me as any more like Rhodes's ideal than I.

Three of the five Occidental men were nominated by the college committee for consideration by the California committee, which would then nominate two men from all the California candidates to appear in the final competition before the district committee. If three seems a rather large number for a small school to send up in one year, I can only say that it was none too large for me. I happen to know that I was definitely the third choice of at least one committee member.

I was now faced with writing an essay of approximately a thousand words in which I was to set down a record of my intellectual development and ambitions, explain why I should be sent to Oxford, and generally display myself to advantage. I have since felt that this was a test not so much of what one might say as simply an indication that the candidate had a certain coarseness of fiber that would be useful to him in later years as a Rhodes Scholar. To ask a young man between the ages of eighteen and twenty-five to write out his ambitions and his own evaluation of himself, and to put the resultant prose into a permanent file, is to ask a great deal.

Whatever illusions I had built up collapsed almost as soon as I set out for San Francisco the morning of Friday, January 4, 1935, to attend the state examinations, held that year at the Bohemian Club through arrangements made by the California committee's secretary, Vincent K. Butler (CA and Worcester '11). A number of young men got on the Southern Pacific *Daylight* at Glendale when I did, and I found that an even greater number had already boarded the train in Los Angeles. I knew that not all of these could be my competitors, but I felt sure that some of them were and I ran my eye over the field. I settled on one certainty, a very tall blond who paced gloomily

down the aisle of my car once or twice and at Paso Robles later in the day seemed to pause for a moment to peer over my shoulder at the book I was holding. I was playing everything safe that trip and had taken along A.P. Herbert's recently published *Holy Deadlock,* which I thought should have the right Oxonian touch.

At the Bohemian Club next morning I met this tall blond man, who was apparently not greatly surprised to find me there. We introduced ourselves and I learned that his name was Horace Davenport and that he was from the California Institute of Technology. Occidental is referred to somewhat obscenely in at least one Cal Tech song, but we were both southern Californians—Davenport having been born in Philadelphia and I in Shanghai—and in San Francisco this was more than enough to start a friendship.

Something a little over twenty candidates gathered in a lounge. One thing that distinguished Davenport and me from the rest was that we were the only men in the room unadorned by personal jewelry. Phi Beta Kappa and Sigma Xi keys glittered here and there; class rings shone in some profusion; almost crippling displays of gold footballs, basketballs, and other insignia hung upon certain stalwarts.

From time to time one of the group would be called out to meet individual members of the committee. My one morning encounter was with a delightful medical man, Dr. Emile Holman (CA and St. John's '14), and I suspected that since my health and my athletic record were not my strongest points, he had been delegated to examine me in something like a medical sense. I had referred in my self-laudatory essay to the mountain climbing I had done in Switzerland during the year I had taken out between high school and college, and to the camping and hiking I had done in the back country of San Diego County during the summer following my sophomore year at Occidental. Dr. Holman asked me how I had stood up on these jaunts, and as one to whom the best doctors of three continents had tried to give tuberculosis, I had some notion of what was going on. For a minute or two I wondered if he weren't going to ask

me to strip to the waist so that he could auscultate me, but he didn't, and we passed on to other matters. Dr. Holman was an able interviewer, and I talked well above myself for fifteen or twenty minutes.

For the rest of the morning I had nothing to do but sit in the lounge and look at my rivals. When luncheon was announced we all went upstairs to a private dining room. Not, however, to sit down. Instead, a crew of waiters circulated with trays of generous martinis. One generous martini would be perfectly correct, but as we stood and stood, chatting now amongst ourselves, now with members of the committee, the problem of the second generous martini presented itself. Clearly it was every man for himself from here on in. I took a second generous martini. Later, unlike some others, I declined a third, having noticed wine glasses at the large oval table in the other end of the room. After the martinis had had time to exercise their full power we sat down and ate an excellent meal. Our wine glasses were kept filled and I felt that though I would probably never get to Oxford I had at least had a taste of what living there would have been like.

After we had eaten, most of the candidates were taken on a tour of the Bohemian Club, but Dr. Holman drew me aside and said he wanted me to meet some other members of the committee. For the first time that day I began to take myself seriously. Soon I was seated in a lounge with B.H. Bronson (MI and Oriel '22) and R.M. Brown (CA and Oriel '32). I sat at my ease, admiring the virtuosity and polish of these two men and chuckling appreciatively at their sallies.

In the early evening we all gathered in the lounge where Dr. Holman had first interviewed me. After a long wait the committee members appeared, looking worn. We were assured that every one of us would make an ideal Rhodes man, and somehow in that atmosphere this sounded perfectly plausible. But a choice had to be made, and it had fallen on Davenport and me.

Sunday I spent on my own in the city. Monday morning I took a taxi to the University Club for the district meeting. The University Club is not quite the same sort of place as the

Bohemian Club. I looked over our ten out-of-state rivals and as soon as I could get Davenport aside I said, "I think we're in!" Davenport, a true scientist, blanched and said, "Shut up— you'll jinx us!"

The district committee sat as a unit. Dr. Holman was a member and when my turn came I had a sense of being taken over the preliminary jumps by a skilled hand. He gentled me along for about five minutes and then turned me over to the out-of-state barbarians. He had done a good job. I was wonderfully keyed up, but under fine control, and I amused even myself with some of my answers, particularly during the rather caustic going-over I got from G.A. Feather (NM and Wadham '17) on my athletic record and my attitude towards organized sports. Mr. Feather, I learned later, had been a private in the Marine Corps from 1917 to 1919 and had represented Oxford against Cambridge in Athletic Sports in 1920, 1921, and 1922.

Back with the other candidates, I was induced to make a fourth at contract. By now my aplomb had left me, and I was horrified to hear myself raise my partner's opening bid with slight justification. He jumped to a small slam immediately and I felt a perfect fool as I put down my cards. I had scarcely noticed my partner at all, but now he said, "Oh, very cleverly bid, partner!"

I looked across the table at an extremely good-looking man with a head of dark curly hair. "Very cleverly bid," he repeated, without a touch of sarcasm in his voice.

By some miraculous and intuitive way he played faultlessly to the slam. "Really a brilliant bid, partner," he said, raking in the twelfth trick.

Dazed though I was, I knew that I had met another Rhodes Scholar in the making and asked him to repeat his name. "Herbert Merillat, from Arizona," he said and spelled out his surname.

The luncheon at the University Club was not, I am sorry to say, a patch on the Bohemian Club's, and we had a choice of milk or coffee. I sat next to a committee member who asked me my views on John Donne and T.S. Eliot. Since my health had

been under discussion again, I felt I should display a hearty appetite by clearing my plate. Somehow between bites of literary-luncheon creamed chicken and green peas I managed to put down a glass of milk and conduct what I hoped was an adequate exposition of what had happened to the metaphysical conceit.

Late in the afternoon we were called to the room in which we had eaten. The chairman assured us that we would all have made excellent Rhodes men, that he was sorry we weren't all going to Oxford. But a choice had to be made and it had fallen on Davenport, Merillat, Clayton White of Colorado, and me.

Walking back to my hotel, I felt my throat starting to burn and suspected I was coming down with a roaring cold. I stopped at a drug store and bought a flask of gargle on the pharmacist's recommendation.

The next morning I couldn't find Davenport in the station, where we had agreed to meet. As the train pulled out I settled down to make the trip alone. My throat was on fire and from time to time I carried my flask to the end of the car and gargled vigorously.

For some time I failed to notice the woman sitting across the aisle from me. When I did look at her I saw that she was inspecting me disapprovingly and I thought she might come from Pasadena. I didn't know why, but I felt compelled, as she stared at me, to say, "I'm just going back to college."

"And where is that?" she asked.

"Occidental," I said.

"Oh?" she said, surprised. It turned out that she was indeed from Pasadena and had a nephew at Oxy whom I knew slightly.

Even this did not mollify her, and when I returned to my seat the next time she asked, "Just why aren't you at the college now?"

"I've been up to San Francisco for the Rhodes Scholarship examinations," I said.

"Well," she answered, "you won't get very far going on this way."

My cold had already dulled me and my eyes were probably glazed. Only now did I realize that the flask of gargle looked like a pint of whisky.

But Cecil John Rhodes was already making his mark. Until that day I would have smiled and explained that I was gargling for a sore throat. Now, however, I drew myself up, and with a crispness of accent that reminded me I had had from my youth in Shanghai a slightly British cast of speech, I stated: "Madam, I already *am* a Rhodes Scholar."

This was my first yielding to the compulsion every Rhodes Scholar feels when he must declare himself—or herself, I imagine, which is, I'm happy to say, a possibility now. It is a habit that grows on one. At first one utters it with a sense of confidence, later with a feeling that the explanation is rather lame, and then—in the courts, in committees, in professional associations, to one's wife and children—it becomes an obsessive excuse. Further stages exist, I understand, but I have not yet reached them.

One of the first problems a new Rhodes Scholar had to face then I was able to evade. Traditionally, each class sailed as a unit from New York for England. Whether or not, having been elected to a scholarship recognizing one's individuality and "instincts to lead," one should promptly fall in with this plan for mass migration is something that even a graduate of an accredited school, fresh from his examinations and privileged to sport a Phi Beta Kappa key, is not always prepared to decide.

For the rest of one's life a subtle distinction is drawn between those who made and those who did not make "the trip." (At least it is drawn by those who did not make it.) I cannot believe that many Rhodes Scholars have gone to quite the lengths that I did in June of 1935 to avoid not only the trip but even the banality of crossing the Atlantic. I sailed on a freighter, *The Golden Hind*, from the Port of Los Angeles, bound for Shanghai via San Francisco and Yokohama.

How many times I declared myself during that summer in China I cannot say, but one clear memory remains. My sister, her husband, and I spent a number of days in Peking and

devoted one of them to visiting the Great Wall. Shortly before we left in the morning we were asked to chaperon a middle-aged schoolteacher from Hollywood who was vacationing with missionary friends. We were to chaperon her on the assumption that my sister and I, having been born and reared in China, would be of great use to her. We smiled wanly, shouldering the responsibility with what little was left in us of the mission impulse.

The schoolteacher proved to be a cooperative companion and had no objection to being hoisted up on a small donkey to ride to Nankow Pass after we left the train. During our picnic lunch on the Wall itself conversation flagged, but we filled in by making comments on the two other foreign parties visiting the Wall that day, one French, one German. As soon as the French group had eaten, they scattered over the area, but the Germans stayed in a group and sang several songs.

"*Sehr gemütlich,*" I remarked.

"So you speak German?" the schoolteacher asked.

My German was, and is, extraordinarily inadequate, and I wondered what stupid impulse had made me speak. With this feeling strong upon me I heard myself declaring in ringing tones that carried out into the wilderness beyond this last bound of civilization, "I am a Rhodes Scholar!"

I dare say I am the first, probably the only, Rhodes Scholar to have made this declaration at Nankow Pass—certainly the only member of the class of 1935—and these nice distinctions are not to be undervalued.

When I boarded the *Conte Verde* of the Lloyd Triestino in Shanghai late that summer, my cabinmates were two young Englishmen, brothers, one a recent Cambridge graduate in medicine, the other still an undergraduate at Oxford. Their parents and mine knew each other casually, and though I'm sure my new friends never felt it as such, for me the trip became an imperial tour to be climaxed by my arrival at Oxford.

At Hong Kong we were conducted up the Peak by a Cambridge man and later motored to Repulse Bay for tea. At Singapore the medical brother replaced the ship's Italian doc-

tor, who had developed appendicitis, and moved from our tourist cabin to first class, from which he occasionally condescended to summon us for a meal or entertainment. At Colombo two Singhalese friends of the Cambridge brother met us and drove us to Kandy, where we admired the lake and entered the Temple of Buddha's Tooth. At Bombay we saw equal parts of the city and the Taj Mahal Hotel. At Port Said we indulged in a little night life. The next day we passed our sister ship, the *Conte Rosso*, loaded with Italian troops bound for Mussolini's war against Abyssinia. At least three of the *Conte Verde*'s passengers failed to cheer.

After a brief stop at Brindisi we sailed up to Venice where the older brother decided to spend a few days. The younger brother and I hurried on; he because he felt guilty about meeting his tutor, I because I was short of money. We had a between-trains look at Milan, and then boarded the Paris Express. I yawned myself awake early in the morning trying to spot Corsier-sur-Vevey, the village above Lake Geneva where five years before I had presumably strengthened my lungs and my French. In Paris we crossed from one station to another and boarded the boat train. In London I spent a night in my friends' widowed aunt's home, the former rectory of a mountain-climbing clergyman. This was a London I knew nothing of, a grimy southern near-slum.

The next day I made my approach to Oxford, this time correctly by way of Paddington Station, and arrived at Merton in the middle of the afternoon. I had written from Italy by airmail asking permission to move into my rooms, but I arrived at the same time as my letter and the Porter obviously disapproved of my turning up in this irregular way. I felt very American and assured him that I could put up at the Mitre. He looked relieved and said that in a day or two I might move in; so I collected what mail had come for me and took a taxi to the hotel.

At Merton two days later I found myself in Fellows Quad in a handsome, almost square, sitting room with a meager bedroom attached. One medium-sized electric heater boasting a

single bar, the sort of heater that grills anything held two feet from it but fails to carry farther, contended with the damp chill. How it could compete with that room I couldn't imagine. I asked the scout if I could get one or two additional heaters or—better yet—open up the bricked-in fireplace. He was shocked.

At this point an old high-school friend of mine, Robert W. Barnett (NC and Merton '34), came to my rescue. Bob and I had not met since he had graduated from the Shanghai American School in 1929, but we had pitched on the same college at Oxford. Bob had already canvassed the situation and knew I would be unhappy in Fellows. He told me that the quad in which he lived, St. Alban's—pronounced Stubbins—had rooms not yet electrified. Perhaps the most easily heated set there—aside from his own—was one that Paul Engle (IA and Merton '33) had lived in during his first year. Bob felt that if I were persuasive, I could get the Porter to trade my rooms in Fellows for these, where the fireplace had, perhaps in error, been built in such a way that it actually threw heat into the room rather than up the chimney.

I undertook a conversation with the Porter, a conversation I was happy Dr. Holman could not overhear. In the end, the Porter felt it could be arranged.

Once I had moved, Oxford at last began to come alive. I had heard of the scouts' traditional way of extorting money from their charges, though I supposed this sort of thing had died out after the war. One common ruse was to "sell" the newcomer furniture that had presumably been given to the scout by the previous owner. My new scout undertook to sell me not only the heavy pair of curtains, made of what I can only describe as teddy-bear material, that lined my sitting room's bow-window, but the window seat as well. He assured me that the curtains helped keep the room warm, which I did not doubt, but they were too heavy for the rods and the College was going to remove them if they pulled down again, but that if I bought them from him this would somehow not happen, or if it did it could be taken care of privately.

ried the window seat, which must have been in place for years, and found it thinly padded, but I couldn't imagine being an American in Oxford without a window seat, especially a window seat that looked impossible to remove. As one who had lived with Chinese servants all his youth, I hardly felt unequal to handling my scout. On the other hand, I was enjoying—and after a longish wait—a little of "the real Oxford."

I shifted on the window seat. "It's damned hard," I said, "and these curtains are really a filthy color."

"Oh, sir!" my scout exclaimed, suddenly uncertain.

In the end we settled on a figure about half of what had been asked, and I have never known which of us was the more pleased: my scout over taking in the innocent American, or the innocent American over feeling truly Oxonian at last.

But the man had shrewder blows to deliver. I watched him unpack my household things. The tablecloths were of Chinese or Irish linen. The silver lacked teaspoons, but included an unusual set of bamboo pattern silver-gilt coffee spoons my sister had passed on to me from her wedding gifts.

My scout handled the linen respectfully and grew close to effusive over the coffee spoons.

I remarked that I would have to buy a set of teaspoons and a few other things.

"Oh, sir, of course," he said. "All the young gentlemen do."

"Where do you think is the best place to go?" I asked.

"Oh, sir, everyone goes to the same place," he said.

"Really?"

"Yes, sir," he said. "Nowadays almost all the young gentlemen buy their things at the Woolworth's."

"At Woolworth's?" I asked sharply.

And my scout said, "Oh yes, sir, at the Woolworth's. They have some lovely stainless steel."

The Long Christmas Dinner Society

ALTHOUGH I FELT THAT I HAD BECOME A Mertonian as soon as I had settled the matter of my window seat and curtains, in the eyes of the world I had two further steps to take. One cannot become a member of an Oxford college without having been accepted as a member of the University; at the same time it is impossible to become a member of the University without having been accepted as a member of a college. To a completely English mind this presents no problem, something that has always persuaded my own Sino-Anglo-American mind that the English enjoy a native predisposition for metaphysics. That Merton—at one time or another the home of such intellects as those of Duns Scotus, Sir William Harvey, F.H. Bradley, Harold Joachim, Sir Max Beerbohm, E.C. Bentley, and T.S. Eliot—manages this is not surprising, but the lesser colleges somehow bring it off as well.

Merton makes a point of this mystic transformation in a matriculation ceremony at which each new member signs the roll and receives a copy of the College regulations. Shortly after the start of Michaelmas Term we freshmen appeared in Hall one morning, presumably in correct academic dress, wearing our gowns over, and our waistcoats under, our suit jackets. Our cicerone for the ceremony was Merton's current Dean,

R.G.C. Levens, dressed casually beneath his M.A. gown, with a sleeveless pullover under his jacket. Levens made some friendly and urbane remarks on how Merton held this little ritual annually, and that though it was in fact the Warden's duty— privilege?—to conduct it, we should feel quite at our ease because the Warden of Merton, Thomas Bowman, a stone-deaf mathematician appointed for life in 1903, had not presided at this event for several years. In a few moments we could expect the doors at the end of the Hall to be opened by the Porter bearing a message from the Warden excusing himself because of the pressure of his duties and requesting the Dean to take his place.

Levens had just finished these remarks and we all felt amiably in the know when the doors at the end of the Hall were indeed flung open, but instead of bearing a message, the Porter bowed in an elderly man in full academic dress who plowed resolutely up to High Table and sat down, glaring briefly at the Dean's pullover. Levens, momentarily shaken, recovered, saying, "And here is the Warden now, God only knows why," in the offhand tones of one speaking in the presence of the deaf.

After welcoming us as a body to Merton, the Warden set to work. The list of freshmen began with what were called Scholars in other colleges, holders of various major grants or distinctions. At Merton these persons are called Postmasters, and as they were summoned in alphabetical order and signed the roll, the Warden kept a sharp eye on them. Among the first ten or so at least four were left-handed. "Extraordinary!" the Warden exclaimed. "I wonder if this portends something."

But left-handedness was not the Warden's true concern. His eyes lit up at the sight of the first Postmaster to mount the steps of the dais unfortunate enough to be wearing a pullover beneath his jacket.

Before allowing this youth to sign, the Warden said crisply, "My good young man, I am sorry to have to tell you this, but you are *undressed!*" As he spoke, Bowman's eyes focused on the chest of a chastened Levens staring into the middle dis-

tance. Bowman continued with a few words on correct dress before asking the miscreant to sign. The rest of us sat either smugly or nervously awaiting our turns.

We had progressed about a third of the way through the list of Exhibitioners—holders of lesser scholarships than the Post-masters—when the prime cause for the Warden's presence revealed itself. Meanwhile, every lefty had received a jovial greeting and every "undressed" freshman a wise, wordless nod. "Ah!" the Warden exclaimed when this particular Exhibi-tioner presented himself. "I am so happy to welcome you. As you know, your grandfather and I were good friends as under-graduates, and I am pleased by the continuity of our relation-ship through your admission to the College."

"Thank you, sir," the Exhibitioner bleated.

"And how is my old friend these days?" the Warden asked. "We rarely correspond, for I'm sure that, like mine, his waking hours are filled carrying out his duties to his people."

The young man cleared his throat and blurted, "I'm sorry to have to tell you, sir, that my grandfather died only last week. We have just notified *The Times.*"

"Splendid! Splendid!" Bowman responded. "I'm delighted to hear it. Now sign your name and give him my greetings when you next write your family."

"Yes, sir," the poor wretch choked out.

We had all frozen, caught in the sad hilarity of this ex-change. But we were, after all, well on our way to becoming Mertonians, and decorum prevailed. What social situation could not be handled in later life by anyone who had kept control through this one?

The ceremony continued, with the Warden snorting at the occasional southpaw and repeating his speculations on the possibility of, if not a national, at least a collegiate trend. As the last of the Exhibitioners signed, Levens motioned to me because I came first alphabetically among that year's Rhodes Scholars. At Merton, though a Rhodes Scholar wears a Com-moner's gown and dines with the Commoners in Hall, in the College roll Rhodes Scholars make up an intermediate cluster

of their own between the Exhibitioners and what we privately called "the even commoner Commoners."

I felt I had nothing to fear. I was correctly dressed and I am right-handed. I stepped up on the dais, bowed, and waited. The Warden glanced at me and turned to Levens, saying, "And now we have the Rhodes Scholars, I believe?" As he spoke I realized that I had, for an Oxonian, been misaccenting the title—if that is not too pretentious an appellation. I still find it interesting that an American automatically stresses the first syllable of "Scholar," whereas the Warden, along with the rest of the University, as I was to learn, gave the heaviest stress to "Rhodes." The reasons for this I hesitate to explore.

Levens motioned me farther forward, shouting, "Yes, Warden!"

Bowman glanced at me again, and said, "Come now, Dean, it's time for the *Rhodes* Scholars."

"Yes, Warden!" Levens bellowed and pushed me a step closer.

Bowman inspected me, and with uncertainty sounding in his voice for the first time, asked "Are *you* a *Rhodes* Scholar?"

I nodded vigorously. "Yes, sir."

"Well, well," the Warden said tolerantly. I was uncertain then, and I am uncertain now, of why he was skeptical. I was, it is true, extraordinarily thin for my six-foot two-inch height, but I was in possession of all my parts, and though not what I would think of as handsome, I was not ugly.

"I don't think we've met?" the Warden asked.

"No, sir," I said, shaking my head.

"Well, you may sign," he remarked, and as I did so he muttered, "Right-handed, thank God." He thrust a copy of the Merton booklet at me, saying, "Take this and *read* it."

"Thank you, sir," I yelled and retreated.

This welcome remains as opaque to me today as it did then, but I have never supposed that the Warden had mistaken me for the Duke of Dorset.

Shortly after the freshmen of 1935 had become full Merton-ians, those of us who wished to become readers at the Bodleian

Library were herded in the front quadrangle and conducted across the High to that unique institution. We waited behind other collegiate groups, and when it came our turn we promised not to bring fire into the library or perform a number of other rash acts, after which we stepped up one at a time and signed our names and college in a full folio register.

A few days later I was asked by one of the second-year Americans at Merton, Richard B. Schlatter (MA and Merton '34), if I knew what I'd actually done.

"What do you mean?" I answered. "I just signed the rules and regulations of the Bodleian."

"That's what I thought, too," he said, "but last year there was some sort of hitch ahead of us, and since I was still in front of the register I turned back to the opening pages, and you know what?"

"What?" I echoed obediently.

"Well, I want to assure you that we've all signed the Thirty-Nine Articles of Faith of the Church of England," he said, laughing.

"It may be a laughing matter to you and me, but I don't plan to write home about it," I said, thinking of my father, firm in his Presbyterian faith.

Father had already got wind of certain drinking customs at Oxford and had written asking me if I found the use of alcohol a problem. I replied instantly with a letter opening "Dear Father: I'm happy to be able to tell you that I am having no problems whatsoever with alcohol here." And indeed I was not, having opened an account with a wine merchant who provided me with a steady supply of Sandemann's Five-Star Amontillado—sherry being the accepted refreshment of my Oxonian generation and the sherry party an established form of correct entertainment—as well as stronger distillations.

As word got around, I could count on three or four visitors every evening a half hour before Hall, warmed by my coal fire and spirits.

This, however, was still to come.

I had applied for admission to Merton because I knew that

the tutor in English literature was Edmund Blunden. At Occidental I had read everything of his that I could get my hands on, and thus knew him not only as a poet, but also as an authority on Keats and Lamb and Leigh Hunt. Like Lamb, Blunden had been schooled at Christ's Hospital and remained a loyal Bluecoat Boy. But above all, Blunden was the author of *Undertones of War,* his memoirs of the First World War, one of the rare classics to come out of that conflict. Known to relatively few American readers, it had to wait for full appreciation by an American critic until 1975, when Paul Fussell devoted a section titled "A Harmless Young Shepherd: Edmund Blunden" to him in his *The Great War and Modern Memory,* in which Fussell also does justice to Blunden's poetry, written outside of anything so facile as the standard definition of "Georgian."

Once accepted by Merton, I had received a welcoming letter from Blunden in which he suggested a few books I might enjoy glancing at in preparation for reading under him, including Henry James's *English Hours.* I had discovered James pretty much on my own at Occidental and I looked forward to my first tutorial eagerly. I was not disappointed. Blunden received me warmly. We exchanged opinions on James, we shared symptoms as occasional asthmatics, and then Blunden waxed lyric in his memories of a brief stopover in Shanghai in 1924 on his way to filling a three-year appointment as Professor of English Literature at the Imperial University in Tokyo, where he had enjoyed himself enormously. I suppressed my China-bred anti-Japanese feelings as best I could, understanding why Blunden, who stood just a little over five feet, would feel at home in that land. But he baffled me when he declared, "For me, Shanghai always means a vision of green fields."

As one born in that cosmopolis on the mudflats of the tidal Whangpoo River, whose boyhood home stood in a compound surrounded by the crowded district of Nantao outside the Little South Gate of the old Native City, Shanghai meant not only the skyline of The Bund and the comfortable—often luxurious—private homes of Frenchtown, but even more the acrid

fumes of public urinals for men, fecal stinks, crowds, traffic jams, a polyglot culture, half-wild dogs mating in cobblestone alleyways, and noise, always noise: brass bands blaring out "There'll Be a Hot Time in the Old Town Tonight" at the head of funeral processions, ropes of bursting firecrackers, the clang of the firetower bell.

As Blunden beamed at me, nodding his head in what I came to recognize as pleased approval, I decided he had been driven swiftly through the city itself, probably out to the Lungwha Pagoda, a popular tourist attraction, and that his pastoral taste had savored the green paddy fields and small farms of the countryside, which in those days lay close to the city, even being a part of it in its outer sections.

"Ah," I said.

Near the end of the hour Blunden sighed and said, with mild irony, "Well, I daresay we should talk a little about your preparing for Schools."

"Yes, sir."

"I imagine you have read some Chaucer?" I couldn't tell if he was still being ironic.

"Yes, sir," I said. "At my American college I completed a course that covered the entire works in Robinson's edition."

"That's promising. We use his text here, you know. I find it amusing—don't you?—that we need Americans like Kittredge and Robinson to expound our first great modern poet."

"Ah," I said again.

"Well, for next week why not put together a few remarks on Chaucer's own view of writing, of poetry, you know—that is, some paragraphs on Chaucer as, to be fashionably contemporary, 'a self-conscious artist'?"

"That should be good fun," I said rashly.

"Most of my charges find it something of a trial."

"Really?"

"Oh, really," he said, smiling. "I look forward to what you have to say. Meanwhile, thanks so much for reminding me of the green beauty of Shanghai."

"Ah—yes, sir," I said, and bowed myself out.

In those days a reader of English had the choice of one of three courses. Courses I and II were heavily philologic and historical. Course III actually came as far as the year of the Reform Bill— 1832—though it still included examination papers in Old English, Middle English, and the History of the English Language. This was the course I had elected, known popularly as "the modern course—for women and Americans."

I had prepared myself fairly well for the Oxford Honour School of English Language and Literature. In my junior year at Occidental I got permission to take the graduate course in Anglo-Saxon, and in my senior year my freshman instructor in English, Professor Guy Andrew Thompson, generously added to his already heavy teaching load a *Beowulf* seminar of which I was the sole member.

At Merton, those reading Course III took their language tutorials not from J.R.R. Tolkien (soon, it was rumored, to publish a "children's book") but from J.N. Bryson, an Old Mertonian associated with Balliol. Bryson, born in 1896, had taken a First in English in 1922 and everyone spoke of him as "a young man of great promise."

Later in that first week I waited on Bryson in the company of two other Mertonians reading Course III: Douglas Valentine LePan of Toronto and Peter Herbert Sparks of Bradford-on-Avon, Wiltshire.

Bryson quizzed us briefly. In answer to some question directed at me I said that I had taken an introductory course in Anglo-Saxon and had also studied the full text of *Beowulf*.

"Indeed?" Bryson replied tolerantly. "We'll just see how it goes next week. Take the first sixty-four lines of that epic, if in actual fact that is what it is."

The chairman of the Occidental Department of English during my undergraduate days was Benjamin F. Stelter. A dynamic classroom teacher, he had exhausted most of his scholarly zeal in performing his share of compiling Broughton and Stelter's *Concordance to the Poems of Robert Browning*. Stelter had taken his degree at Cornell under Lane Cooper, "a concordance man"; so I knew how to go about my Chaucer assignment.

I found Tatlock and Kennedy's *Chaucer Concordance* in the English Reading Room of the Bodleian Library, its pages feeling as if they had seen little use. I copied every reference under such headings as "writing," "inditing," "making," "poesy," and so on, as well as entries for Homer, Virgil, Boccaccio, Dante, Petrarch, Lucan, and even what I believe is the single mention of Statius. With all this in hand I returned to my warm coal fire, and with my copy of Robinson I set about classifying Chaucer's lines and arranging them in what I felt were appropriate clusters. The next morning I typed out a first draft, shifted things around a bit, and later in the week I knocked out a clean copy.

When I finished reading this to Blunden the following Monday morning, carefully declaiming all the quotations in my best Middle-to-Modern English accent, Blunden remained silent for what seemed to me an interminable length of time. I knew perfectly well that a part of the tutorial system's merit lay in having one's first essay torn to shreds, and though I found it difficult to believe that Blunden could even approach anything like malice or cruelty, I supposed he was gathering his strength for the attack.

But when he spoke at last it was to say with a note of bemusement in his voice, "Good God, Espey, you haven't missed a thing! In fact, you've brought up some references that I myself had never thought of as pertinent, though I can see that they are."

"Ah," I said, still uncertain.

"And I think you are wise in leaving the whole question of the 'Retraccioun' pretty much up in the air. After all, who can say?"

"Certainly not I, sir," I answered, gathering confidence in the possibility that I may have performed an acceptable job.

"Normally, your second essay would be on the origins of the English drama."

"Oh, dear!" I heard myself saying and started to apologize, only to have Blunden interrupt with "Not at all—I feel the same way myself, but please be good enough not to quote me."

After questioning me on a number of standard English writers Blunden suggested that I might enjoy planning my own course of reading, filling in gaps and following whatever personal interests I had. We could talk these over during my Monday tutorial hour and I wouldn't really need to write an essay—simply jot down a few notes.

Anyone in his sane mind would have seen instantly that this was not the ideal plan for advancing an American academic career, a calling that made a doctoral degree essential. But I was so overcome by the fact that I was sitting there, talking on almost equal terms with one of the most distinguished writers of the day that I fell in with it immediately. The tutorial system was proving to be even more remarkable than I had ever imagined.

At this distance, what strikes me as truly remarkable is that I had many examples among my friends of the solution to my problem. Dick Schlatter had decided to go on directly to a D.Phil., with the odd result for my own scholarly career that the first bit of lore to be connected with my name is a footnote in his *The Social Ideas of Religious Leaders 1660-1688* (Oxford, 1940), quoting a passage from one of Donne's sermons reflecting the Anglican stand of his day against the use of contraceptives. My classmate and good friend Rhodes Dunlap (TX and St. Edmund Hall '35) had decided to devote his first two years to a B.Litt. in English and then go on for his D.Phil. with an edition of Thomas Carew. A friend of Davenport's, William L. Sachse (CT and Balliol '35) had opted for a B.Litt. in history for his first two years and would then return to Yale to complete a Ph.D. These are only three of several examples, but in spite of them I continued under the spell of the tutorial system.

My second session with Bryson led to nothing like the freedom resulting from my use of the Chaucer concordance. LePan, Sparks, and I dutifully showed up and in turn translated and answered questions on individual points. So far as I could judge, some of this was new to LePan and Sparks. I had reviewed my old notes rapidly and even attempted to write

down a smooth translation. Perhaps the fourth time I was queried by Bryson on some point of grammar or etymology, the hour had almost ended.

"I must say, Espey," Bryson remarked, "you do this rather well."

"Perhaps you'll remember, sir," I said, "that I've already taken a full course in Anglo-Saxon as well as a sort of private *Beowulf* tutorial."

"Ah, yes," he answered and paused. Then he drawled tolerantly, "That was, I believe, in California—by the shores of the Pacific?"

"Yes, sir."

"So I thought," he said with the hint of a sigh. "Just take the next one hundred lines for the coming Wednesday."

Bryson's "own work" at the time was known to be the compilation of a glossary for the New Temple edition of Shakespeare being prepared by Balliol's tutor in English, the Rev. M. Roy Ridley. This edition is generally agreed by specialists to be probably the least adequate to appear during this century. The compilation of a Shakespeare glossary's most demanding requirement is to avoid any accusation of plagiarism.

At least I became good friends with LePan, who hoped to enter either the academic or diplomatic circles of Canada, and Sparks, who confessed that his boyhood dream had always been to become an officer in a Gurkha regiment. As it happened, he was to realize this soon enough, just as LePan was not only to realize both of his desires, but also to become a distinguished poet and novelist, one of the very few Canadian writers to win Governor General's Awards for both poetry and fiction. We eventually worked out a more or less casual arrangement that required no more than two of us to turn up at Bryson's each Wednesday.

Pleasant as all this was, I felt that I was still missing something. As a freshman, I dined in Hall with the other freshmen, most of them five or six years younger than I. Conversation was halting. My second- and third-year American friends all seemed to know fluent, witty characters, full of gossipy small

talk. Among them was Denis Barnes, now Sir Denis, after serving as Permanent Secretary in the Ministry of Labour and the Department of Employment. Peter Sparks introduced me to a man named Frank Harley, who was to become a lifelong friend. I was elected to the Bodley Club, Merton's presumably "intellectual" social group, where I got to know W.H. "Richard" Walsh, whose first book, *Reason and Experience* (Oxford, 1947), opened a fruitful career in philosophy, leading to a professorship in Edinburgh.

But when it came to my fellow freshmen, I decided that Merton had gone into a sudden decline. Only at the beginning of my second year did I learn how intense and crucial a period of transition that first year at the University was for young Englishmen. What an American acquired during his four or five years at either prep or high school, an English youth had to manage in that first year of what to him was sudden freedom.

Always the optimistic and sentimental American, I encountered briefly what I thought was a typical example of the well-known donnish cleverness at the end of my first term. In a ceremony familiarly called a "don rag," each undergraduate of the College appeared before its Fellows to listen to reports on his progress and to receive advice on his future behavior, both academic and social.

The Fellows, gowned, sat behind a long table, the Senior Tutor presiding, and we were summoned before them one at a time. When my turn came, Blunden's report generously said that I was a promising candidate for Schools and knew much beyond the bounds of the standard texts. Bryson sent in a report stating that I had "an acceptable familiarity" with Anglo-Saxon and was doing more than merely satisfactory work.

The Senior Tutor, Idris Deane-Jones, raised his eyebrows and smiled. "Really, Mr. Espey, these are excellent reports. Usually we find Americans reading English seriously deficient in their knowledge of Anglo-Saxon."

"Thank you, sir," I said.

"Not at all," he replied, still smiling. "I think we can say in summary that you have taken your first steps here at Merton with both feet firmly planted on the ground."

I grinned and was on the point of replying that I hoped to continue leap-frogging my way to a degree when I saw from the bored slouches of the other Fellows and the Senior Tutor's sudden seriousness that none of them had found anything amusing in his splendidly static trope, and when this was followed by "That will be all—do have a pleasant holiday," I controlled my face, rose and bowed, and made way for the next undergraduate in line, managing to get out "Ah—thank you, sir."

Meanwhile, Davenport, over in Balliol, had been asked by that college's English Club to read a paper on contemporary American poetry. He invited some of his American and Canadian friends to hear him, and entertained us in Hall at Balliol before the evening meeting. We did ourselves rather well at this meal on the indifferent Madeira laid down in such quantity by a former Master, the great Benjamin Jowett, that it had been made available to undergraduates. As we waited for the hour of the meeting in Davenport's room, still swilling down Madeira, one of us said, "You know, the English are so fond of hoaxes, it could be fun to pull one on them. How about inventing an American poet not yet generally recognized but of great quality and rebuking Horace at the end of his paper for not mentioning him?"

This seemed a reasonable enough proposition as we tackled yet another bottle of Jowett Madeira, and we created the great, but as yet not widely known poet, Elias Cabot—a New Englander, I hardly need say, but one who had found the stony soil of his native Massachusetts too barren for support and had daringly moved to a New Jersey cranberry bog where he lived in almost complete isolation.

Cabot's first book, *Rooted Green,* expressed his affirmation of life, but, once it was out, he had experienced a revulsion against nature and his second slim volume had taken its title, *Nadders and Pads,* meaning "snakes and toads," from a phrase

in *The Peterborough Chronicle*. Finally rid of his negative confusions, he had then achieved a radiant unity of vision in his third volume, *Wedded Brick,* a true synthesis of his former works, and only God knew how far all this would lead him when he published his fourth volume, on which, as we understood, he was at work—a masterpiece as yet untitled, but rumored to be a patterned composition of possibly epic length.

And so, after Davenport's survey had been read and was being discussed, one of us brought up the name of Elias Cabot.

Davenport excused himself for not mentioning this coming man because of Cabot's lack of general recognition even in his own country and because no English publisher had been perceptive enough to pick up on him. Another of us tended to agree with this decision but thought it a pity not to mention Cabot at least in our discussion as probably *the* coming man. I myself risked quoting a line or two from one of the sonnets included in *Nadders and Pads* that opened "Give me the pastel of some lesser god."

Then a dreadful thing happened. Our first victim was not an Englishman but an American from Yale, who obviously couldn't afford to admit ignorance of this important compatriot. He wondered if Cabot's work couldn't be taken to be the poetic equivalent of Thomas Wolfe's prose. We agreed grudgingly that there might be some superficial similarities, especially in *Rooted Green,* but that Cabot's lines contained none of the extravagantly sentimental lyricism that many critics felt to be Wolfe's chief weakness.

Next we caught our first English victim, a man whose mother had published some biographies and researched one of her subjects in the Library of Congress. He confessed that now he had actually heard the name of Elias Cabot, he did recall his mother's mentioning him as someone she had been told to read, though he was not certain that their country house library actually contained any of Cabot's books.

Naturally, this man was not to be allowed to score alone and others, their memories jogged, came up with literary relatives

of discriminating taste who had almost certainly noticed th___ rising star of the West.

And so it went on for some time, with one or another of us dropping memorable lines of Cabot's as they came to mind. Jowett's investment had at least been put to some creative use.

We had to pay. Blackwell's, the great Oxford book center, received two or three orders for the works of Elias Cabot during the following week. Blackwell's, alas, was well up on *Books in Print*. Failing to find the immortal Cabot listed, Blackwell's suggested that the elusive works may have been privately printed. That was not their understanding, the Balliol men insisted, and even came up with a detail or two of Cabot's contributions to literature.

In the end, we learned that though the English enjoy perpetrating hoaxes on others, they, like lesser mortals, take a dim view of falling for one themselves. Though almost all was forgiven in time, one or two Balliol men, including an American from Yale, remained chilly during the following years. But Cabot's work is not entirely forgotten, having been plagiarized, suitably enough, by one "Algernon du Jardin." If anyone wishes to read a few more details of his remarkable achievements, they can be found on pages 33 through 37 of *The Nine Lives of Algernon*, published by Capra Press in 1988.

The title of this chapter comes in part from this caper. Four of those involved happened to be dining together when Bill Sachse got news that his edition of *The Diary of Roger Lowe of Ashton-in-Makerfield, Lancashire 1663-74*, had been accepted for publication in England by Longmans and in America by Yale. We decided to celebrate this auspicious opening of his career by forming a dining club, and since Bill was an admirer of Thornton Wilder's shorter plays we became The Long Christmas Dinner Society.

Our membership consisted of Davenport, later to be known throughout scientific circles as "ABC" Davenport in salute to his *The ABC of Acid-Base Chemistry* (1947), followed by authoritative studies of human digestion, after which he turned himself into a historian of medicine; Sachse, who was to spe-

cialize in Norwich Court records among many other subjects; myself; and Robertson Davies, the Canadian playwright, essayist, and novelist who, if only Ottawa would stir itself a little on his and its own behalf, should by now be a Nobel laureate.

In the finest spirit of democracy our first order of business was to close the society's membership for life. Our sole function was to dine at least once a term at the expense of one of the members. My first time around I was able to conclude our repast with the Merton chef's specialty, a quivering lemon soufflé. At perhaps our most memorable meeting, Davies played host on St. David's Day, and our feast included a dish of leeks. When we rose, Sachse was moved to lift the candelabrum from the center of the table, and, candle flames streaming, demonstrate his grace in performing the minuet as he had learned it in dancing school.

Though admittedly self-indulgent, we were ready with a "worthy purpose" for the larger public if challenged. In those days it was repeatedly impressed upon us that no young man could hope to survive the vicissitudes of spending three dank winters in the Thames Valley without taking regular, strenuous exercise. We were willing to risk our health for the benefit of future generations in order to prove this assertion fallacious. As of this writing, all four members of The Long Christmas Dinner Society, close to entering their ninth decades, remain actively engaged in their diverse interests. A clear case of *paresse oblige;* for, to date, we have received no public honors for undertaking this potentially life-threatening experiment.

And so my Oxford education advanced. My second summer witnessed the retirement of Warden Bowman and the installation of Sir John Miles as the new Warden of Merton. A few undergraduates had asked permission to stay on in college for further study, and the Fellows generously invited us to join the noonday festivities in Hall. Everyone attended in full academic fig. Scarlet robes made bold splashes of color. Subdued at first, the decibels began to rise after the opening course—Russian vodka neat with Beluga caviar. They continued to rise with

each new course and its appropriate wine. At the end, after Sir John had acknowledged a tumultuous greeting, we staggered out into the front quadrangle as the changes were rung on the Merton Chapel chimes.

Blunden sought me out, having been seized again by the vision of Shanghai Green and wishing to talk about it further. We supported each other to the nearest stop for a bus that would take us to the Blunden flat in North Oxford. Somehow, our conversation had leaped to a consideration of modern poetry, including that of our fellow Mertonian, Thomas Stearns Eliot. We just made it onto the rear platform of a bus as it pulled away from the curb. I had grabbed a stanchion to steady myself, and Blunden, blissfully unaware that he was cradled at an angle in my elbow, looked up into my face, his eyes lit like a Shelleyan spirit's, and said, "As to those chaps, I'm still not quite certain where I stand."

For two years I made my way through fresh woods and pastures new, reading widely among the so-called "minor" writers of various periods, hunting down my private enthusiasms, and looking forward to each Monday morning that always yielded an informative and entertaining exchange with Blunden. During those two years I enjoyed listening to him reminisce on his visits to Thomas Hardy, who had been one of the first important literary figures to praise him, and a number of other important writers. From time to time he spoke briefly of his war experiences and at length on the problems of sharing rooms with Robert Graves after the war and Graves's advice on ending his first marriage.

On one occasion when the name of Sir Edmund Gosse came up in some connection, Blunden smiled and said, "Not the most accurate scholar. And he had a way of animalizing persons he met."

"I'm not sure I understand."

"Well," he said, with more of a glitter in his eye than usual, "if he had run into you somewhere and heard you mentioned later, he would probably have come up with something like,

'Ah yes, Espey! I do recall him—American, tall and thin—a regular secretary bird.' "

I laughed at the apt comparison, but I failed to understand the feeling in Blunden's voice until I came upon a reference to him later in one of Gosse's letters: "He looked like a chinchilla, with his grey clothes, sharp nose and wonderful eyes. What eyes! Those of Keats must have had that expression." Apparently the comparison with his favorite poet had not quite taken the sting out of the "animalization."

Two particularly enchanting "tutorials" stand out in my memory. The first occurred on a spring morning when the air was fresh and Blunden felt we should, as a pair of former asthmatics, walk through Christ Church Meadows instead of cooping ourselves indoors. As we strolled down to the Isis, hearing bird calls and occasionally catching a glimpse of the birds themselves, Blunden identified each call and then ran it through the history of English poetry, giving references from Chaucer to the moderns. On the second occasion Blunden decided that instead of meeting on Monday we would postpone the session to the following Saturday. If the day proved fine we would take a bus to Abingdon and walk through one of his favorite bits of countryside. This we did, and Blunden expressed disappointment, as we leaned over the rail of a rural bridge, at the paucity of fish, nevertheless naming off two or three varieties that remained altogether invisible to me. Then we walked across open fields and on our return stopped in at one of the Abingdon pubs. I had assumed that he was simply treating me to what he thought of as a little of England's best, not realizing his full and touching intent until he said, as we downed our pints, "Now you can see that you needn't feel homesick for the green fields of Shanghai."

All went well until I realized near the end of my second year that, although I had filled in most of what I saw as the gaps in my reading, I had done nothing to refresh myself on the subjects most likely to show up on the all-important examination papers. In a mild panic I set off on a whirlwind review. I still held the sentimental American illusion that Oxford would

have worked a mystic transatlantic sea change on what I had learned at Occidental. This surely had been Bryson's feeling in insisting that I repeat what I had already covered "by the shores of the Pacific."

Alas, this had failed to occur, at least for me. Chaucer remained the familiar Chaucer, Donne's "strong lines" had neither waxed nor waned, Milton persisted in his heresies. I approached the finals feeling a complete idiot, but I wrote resolutely through the papers, six hours a day, with a weekend break in the middle of the ordeal.

The most trying part of the Oxford system for an American was still to come. The oral examination, the *"viva,"* lay ahead, a matter of a couple of weeks or so of delay, giving one the chance to wake in the night to the horrid memory of some banality set down in the haste of composing an essay.

When my name was posted I sat through an entire day of waiting, witnessing either the success or, what seemed to be the more frequent, failure of the tutorial system. One candidate was reduced to tears, and another finally lowered his head into his hands, waiting in silence to be dismissed. Whatever was in store for me, I decided to hold my head high and say, "I'm sorry, sir, I don't know the answer."

Late in the afternoon of my second full day of waiting I was finally called. Professor Nichol Smith opened with a remark that rocked me as he leafed through the pages of an examination booklet. "You are, I take it, Mr. Espey, not especially familiar with the works of Chaucer, having chosen to say nothing of his work?"

"On the contrary, Professor Nichol Smith," I answered. "I believe you will find that I wrote on the question centered in *Troilus and Cressida.*"

"Indeed?" he asked skeptically.

I took a good look at the handwriting on the front of the booklet. "I'm sorry, sir, but I think you may have someone else's paper there," I ventured.

He looked at the cover, then put the booklet down. After

finding mine he glanced through it and said, "I meant, of course, *The Canterbury Tales*."

Actually, I thought I had shown some enterprise in avoiding the obvious and had put together a quite decent, even perhaps original, paper on the imagery of *Troilus*, positively larded with quotations. "Imagery" was very much an "in" approach in those days, but it was clearly not, in Professor Nichol Smith's eyes, one to be smiled upon. Instead of being asked to expound upon what I had written I answered a few unchallenging questions on the text of the *Tales* and was soon passed on to my next examiners. I immediately sensed the routine quality of their questions and understood that I was, as the last examinee of the day, someone to be taken care of politely and at just sufficient length to let them get to their drinks with clear consciences.

Until the final class list was posted, I tried to persuade myself that I might actually get a First, but I knew better. In this connection I have always relished a distinctly Oxonian heresy. It goes to the effect that a candidate with a feeble smattering of learning will get a Fourth; one with a "gentleman's" knowledge will get a Third; a candidate who knows exactly as much as the examiners (or preferably just a little less) is a certain First; and the unfortunate character who knows more than the examiners is a sure Second. Obviously this is a base canard—and yet. . . .

That should be the end of this chapter, except that in those years no division was made in the list between low and high Seconds, as is done now. Throughout my succeeding career I have never heard another Second claim anything other than that he or she took "a high Second," "a very high Second," or "a very high Second indeed." How these persons know this I cannot say, unless it is through their feeling of native superiority. Once the list is printed the examination papers are burned—alas, the forever lost, brilliant analysis of imagery in *Troilus!*—and there is no appeal. With so many High Seconds in the field, I have been forced to conclude and have always maintained that I am one of the few Low Seconds of my generation. I have yet to meet another.

And that should really be the end. But it seems only courteous to say something about Bryson's subsequent years. His glossary in the New Temple Shakespeare escaped the kind of critical comment that Ridley's eccentric text received. He advanced in due time to the post of Balliol's tutor in English, still known as a Mertonian who had taken a brilliant First, "a young man of great promise." That he remained this to the day of his death mystified only those who were unaware that he had actually peaked early, at the disgracefully green age of forty, in the pages of the June 27, 1936, issue of *The New Yorker* in what I was later to learn the editors call a "newsbreak":

> Mr. John Norman Bryson is being greatly entertained here as the guest of the Cincinnati Branch of the English Speaking Union and has proven so interesting and adjustable that he has really become something of a vogue among those who have entertained him.
>
> He is not a delightful person himself, but he is a scholar, as a lecturer and tutor in English literature at Balliol College, Oxford, one of the world's greatest educational institutions, should be.
> —*Cincinnati Enquirer.*
> A host can't expect to have *everything*.

If one substitutes "A tutorial candidate" for "A host," Eustace Tilley's comment is as accurate a summary of my feelings about the tutorial system as anything that I could compose on my own.

Biting the Hand

ONCE IN POSSESSION OF TWO BACHELOR'S
degrees, I made a quixotic attempt to solve my aca-
demic predicament. And it was, I knew now, definitely an
academic one. My other possible choice had been journalism.
Late in my second year at Merton Dr. "Harry" Luce, an old
family friend from China, had called from London to say he
would enjoy a look at Oxford and accepted my invitation to
have luncheon in my rooms. During our subsequent stroll Dr.
Luce told me that one of the reasons he had come up was to let
me know that his son, Henry, would be happy to find a slot for
me in his organization.

I thanked Dr. Luce but remained hesitant. My parents had
left Shanghai under gunfire during the second Japanese attack
on the city in 1937 and were now in the Philippines. As a
subscriber to *Time* magazine I had become a popular source of
information for my English friends on the developing romance
between Edward VIII and Mrs. Simpson—censored for many
months by the British press—but at the same time an unhappy
reader of that weekly's reports on the war in China. I had access
to other sources of information, and *Time* seemed to me to be
giving the American news-reading public a distinctly skewed
view of Oriental affairs. Quite apart from this, I was not at all

sure that I would stand up well under the varied pressures journalistic assignments and deadlines.

Meanwhile, Occidental had assured me that I could join its faculty as an Instructor in English in another year, and I had also received a tentative offer from a small denominational college in Ohio, an institution that my paternal grandfather had attended for one year and referred to, for the rest of his life, as "that lie factory"—on what grounds I didn't know, though I assumed they were theological. We were living in the depths of the Great Depression and I felt extraordinarily lucky.

Even though I had achieved the only Low Second in English known to man, I was still entitled to a third year on my scholarship. In some instances, third-year men had been permitted to attend Continental universities if their specialties justified this. It occurred to me that, with a certain facility in French, I could probably manage in a year to complete most of the requirements for a *doctorat de l'université,* actually a very humble degree, but one, nevertheless, that would give me the coveted title of "Dr."

At one of our tutorials, Blunden, having spent the weekend in London, where he had picked up some books in the Charing Cross district, handed me an anonymously published novel titled *Democracy* and asked if I would be good enough to tell him what I knew about it since it had clearly been written by an American of distinct literary quality.

I told him that it was one of the two novels published by Henry Adams, and when he looked at me inquiringly I went on with a thumbnail sketch of the Adams family's role in American political and literary life.

I knew about Adams's novels only because I had originally planned to spend my undergraduate years at the University of Wisconsin, my mother's school, having been attracted by the program of Alexander Meiklejohn's Experimental College. During one's freshman year one studied Periclean Athens in all its aspects, and one followed this during the sophomore year with a survey of contemporary American life, using as one of the basic texts *The Education of Henry Adams.* During the free

53

year between high school and college that my parents gener-
ously gave me—a year split between living with a French-
speaking family in Corsier-sur-Vevey above Lake Geneva
under the informal guardianship of Percy A. Scholes (who was
then hard at work on his *Oxford Companion to Music*), and
touring the United States—I had tried to prepare myself by
mugging up on Periclean Greece and reading the *Education*. I
found the latter so engrossing that I went on to read everything
of Adams's that I could lay my hands on.

During the middle of that year I was accepted by the Experi-
mental College. The following day the Wisconsin State Legis-
lature cut the College out of the University's budget, allowing
only those already in their first year to complete their second. I
have no reason to think that this was a case of cause and effect,
but it did lead to a change of plans for me, one far too com-
plicated to be dealt with here.

I felt enormously pleased with myself as I spoke about
Adams and didn't know whether to be flattered or amused
when Blunden said, at the end of my little lecture, "As soon as
I picked up the book—the prose is interesting, isn't it?—I knew
you would be able to tell me about the author."

"You are too kind," I said.

It had occurred to me later that, the appearance of *Demo-
cracy* having caused a considerable stir in the French press of
the day, and Adams's second novel, *Esther*, by "Frances Snow
Compton," having received little attention, I could probably
cobble up an acceptable dissertation for the lowliest French
doctorate. Conscious of my Huguenot ancestry, I suggested to
the Rhodes Trustees that I might profitably spend my third
year in research at the University of Montpellier. I thought that
a request for a year at the Sorbonne might be interpreted as a
request for the pursuit of pleasure rather than learning, even
though I knew that most of my research would have to be
carried out at the Bibliothèque Nationale. I felt it impolitic to
explain that the B.A. I had earned and the B.Litt. that I could
hope to take at Oxford in my third year would count for almost
nothing in the American academic world.

The Trustees' response came as no great surprise. They replied that, since I was working in English, or possibly American, material, Oxford appeared a more practical center for such study than a university in the south of France. They would be happy to grant me a third year if I wished to pursue the degree of B.Litt. in English Language and Literature.

A few years before this, the Faculty of English at Oxford had decided that, whereas the requirements for a B.Litt. in lesser subjects—such as history, philosophy, economics—required no more than a year's research, English comprised an area of such complexity that candidates offering a thesis for the degree must first qualify by attending lectures—some of them actual classes—and passing both written and oral examinations in the history of Anglo-Saxon studies; paleography; the history of printing (including the operation of a hand press); bibliography in all senses, including the history of European libraries and a knowledge of the cataloguing methods in use at the Bodleian, what was then called the British Museum Library, and the Bibliothèque Nationale; the biography of Shakespeare; and textual criticism and analysis. Only after all these had been mastered in some measure could a candidate for the B.Litt. in English be trusted to undertake original research, to which a second year would be devoted. After the resulting thesis had been written under an appointed supervisor and successfully defended in a public oral examination the degree would finally be granted.

Nevertheless, the University statutes still allowed a B.Litt. candidate in any subject to submit a thesis and apply for a public examination at the end of three terms in residence. It should go without saying that almost every candidate in English planned to complete the degree in one year. The candidate attended the required lectures and classes, passed the written and oral examinations, and submitted a thesis a week later —the thesis that the candidate had just been qualified, at least in the eyes of the Faculty of English, to set out upon a week earlier. The actual requirements for a B.Litt. were, in fact, far more demanding than those for a D.Phil. except for the

expected length and "originality" of the latter's dissertation.

Blunden and I had spoken from time to time, after our discussion of Henry Adams, of the reception of American writers in the English press and worked out a possible B.Litt. proposal that would be more acceptable than what I had suggested for my French venture. Part of Blunden's curiosity stemmed from his interest in the members of the Keats family who had emigrated, and part came from his detailed knowledge of nineteenth-century periodicals. He would make the ideal guide, and at the beginning of my third year I addressed a request to Professor David Nichol Smith, head of the Faculty of English and Merton Professor of English Language and Literature, for permission to undertake study for a B.Litt. thesis titled *English Criticism of American Literature: 1832-1892*.

In due time I received a request to wait upon Professor Nichol Smith at his house in Merton Street, and over an indifferent sherry we discussed my proposal. Nichol Smith was far from encouraging. He pointed out that some members of the Faculty doubted that such a subject as "American Literature" existed, though he hastened to assure me that *he* knew that Longfellow was an American. I tried to express some measure of gratitude at this admission, which baffled me until I remembered that a bust of Longfellow stands in Poets' Corner of Westminster Abbey.

I mentioned Blunden's name.

"But these dates, Espey," Nichol Smith said. "They are untidy, indeed meaningless."

I said that the year of the Reform Bill seemed to mark an increased interest in America, and that although the American Civil War interrupted most communication between England and America, I hoped to carry my research through to the deaths of Emerson, Thoreau, Hawthorne, Melville, and Whitman.

Nichol Smith looked skeptical. "This is, I'm afraid, most irregular, but perhaps not hopeless." He went on to say that in any event I had plenty of time during my first year of working toward the degree to reconsider and hit upon something not quite so unorthodox.

"Ah," I said. This was not the time to say that I had already started my research and planned to complete the degree within the earliest possible statutory limits.

In a few days I received an official notification to the effect that the Faculty of English had given approval for research towards the degree of B.Litt. with a thesis to be titled *British Criticism of American Literature during the Period 1800 to 1850 as Reflected in the Periodicals* under the supervision of M.R. Ridley of Balliol College. Both the title and my supervisor's name startled me. I found Blunden apologetic. He had mistaken the date of the meeting and been off at the estate of his good friend and fellow poet, Siegfried Sassoon, who put on an annual cricket match between his houseguests and the local village side.

Nothing could be done on that score, but I did wait upon Professor Nichol Smith again. And again, over indifferent sherry, he remained unencouraging. I felt bold enough to say that these new dates as approved were truly meaningless.

"What do you mean, Espey? Meaningless? That's *the first half of the nineteenth century!*"

Indeed it was, and I was powerless to effect any change in the calendar.

Before undertaking the editorship of the New Temple Shakespeare, Ridley was known as "the don who married a B.Litt. thesis." He had supervised an American woman's thesis on Keats. After she received the degree they married, and two years later, in 1933, Oxford published *Keats's Craftsmanship* by M. Roy Ridley. In its Preface he expressed thanks to a variety of persons:

> First to my wife, whose book it largely is, without whose criticism and patient assistance over vexatious details it would have been a great deal more imperfect, and without whose earlier work on the subject it would hardly have taken shape at all. Whatever is here of value in regard to Keats's 'sources' was lying inaccessibly interred in an unpublished thesis of hers—pyra-

57

midally but not otherwise extant—and she urged me to
open the pyramid and rifle the tomb.

I leave it to the reader's invention to recreate the variations
we played on the concluding image in relation, among other
activities, to the begetting of the Ridley offspring.

I never met Mrs. Ridley, but she influenced my life; for I
learned that Ridley had been appointed my supervisor because
his wife was an American. "Not only that," he was reported to
have said, "I have driven as far as Kansas in a motor car." What
more could I ask for? A great deal, as a matter of fact, but for
the present I had no choice but to wait upon the Rev. M. Roy
Ridley in his rooms in a rear quadrangle of Balliol. Luckily,
we were able to agree that the supervisorial sessions should be
held every other Friday afternoon at 5 o'clock. Luckily, because
Ridley enjoyed further local fame as "the fastest sherry drinker
in Oxford." To complete the Ridley legend I should add here
that he could be a dazzling conversationalist in the best, and
worst, Oxford tradition, a master of small talk and insinuating
gossip, always up on the "truth" going on behind public
events, and never so gauche as to come anywhere near "talking
shop" on social occasions—the ultimate sin even for a man
who had begun his career as an Anglican clergyman and
Chaplain of Balliol. He had once sat next to Dorothy Sayers at
a dinner party and as the ladies rose to retire she was reported
to have said, "I never thought to meet Lord Peter in the flesh."
Inevitably this grew into the myth that Ridley was the original
model for the all-knowing Lord Peter Wimsey, a myth that
Ridley did nothing to dispel.

During our first session Ridley assured me archly that he was
indeed very fond of "things American," and that he had spent a
year at Bowdoin College as a visiting professor. When I
brought up the problems of my thesis's dates, he waved all
difficulties aside, and I discovered that he chose to pronounce
"thesis" with a short "e" and came close to lisping the letter
"s." I found this an almost international challenge, and for the
remainder of the year Ridley produced a more and more drawl-

ing "thethith" in response to my longer and longer "theeesis."
Whatever the true "Oxford accent" is to others, for me it is
permanently lodged in a back quad of Balliol, produced with
the help of rapidly emptied glasses of superb sherry.

When we came to specifics, I said that I was quite unhappy,
because a bit of preliminary digging indicated that at least two
of my principal subjects would be Washington Irving and
James Fenimore Cooper, neither of whom interested me
greatly, though I certainly had nothing against them. Ridley
casually assured me that I would certainly turn up some fasci-
nating information.

"Cooper was known as 'the American Scott,' " I said. "They
admired each other's work and actually met in Paris at a grand
affair staged by the Princess Galitzin, with the attendant
youths draped in tartan."

"Why not publish a small paper on that?" Ridley asked
enthusiastically.

"Ah," I said, tentatively holding out my empty glass. "This
is marvelous sherry."

"I like it myself," he said, pouring for me, and I thus avoided
having to say anything about writing a paper on information
that could be found in more than one general encyclopedia.
My first session with Ridley ended on this somewhat ambigu-
ous note.

Meanwhile, I had the required lectures and courses to attend.
Memory is treacherous, but I believe firmly that we were a
group of twelve at the start. We got to know one another at our
regular meetings, but for me no lasting friendships developed.
One by one they dropped any plan of taking the degree in one
year, discovering such merit in their subjects—all of which
sounded depressingly routine to me—that they saw the wis-
dom of devoting two, if not three or four, years to their studies.
After all, what were a few more years when the result of one's
research might well change the entire course of, if not world, at
least literary, history and criticism?

I alone, the Judas of our year, forged on with the original
plan, working during the week at the Bodleian, and spending

most weekends as well as both vacations in London at what
was then known as the British Museum Library—now the
British Library *tout court*. In that ideal center of research and
toleration of almost any eccentricity, I usually enjoyed the
company of Rhodes Dunlap, pursuing the poems of Carew in
commonplace books, or Richard Cobb, a fellow Mertonian
and member of the Bodley Club, who was already at work
probing the origins of French Revolutionary factions that
would lead him to a fellowship at Worcester College and
eventually a professorship.

Cobb and I had shared an unexpected distinction during my
second year. On our way across the High one morning, either
going to the Bodleian or—more likely—a coffee house, we
heard one of the city-licensed Oxford guides saying to a group
of tourists, "Ah, ladies and gentlemen, you are fortunate
indeed today! If you just look over there you will see Lord
Oxford and Asquith—the tall gentleman—and one of his aris-
tocratic friends."

Cobb and I turned to catch a glimpse of this young peer who
never showed up at parties he was supposed to attend, only to
find ourselves the targets of perhaps a dozen pairs of eyes, most
of them American, gazing at us reverently.

What would Cecil Rhodes feel correct for this occasion?
Actually, Cobb and I, with only a flicker of hesitation, found
ourselves bowing from the waist, and after a wave of the hand,
turning to go on our way, leaving behind a rising buzz. From
time to time Cobb rallied me on my elevation to the peerage,
and I usually responded by saying that anyone could see that
he had to be the descendant of a royal bastard.

Pleasant as all this was, I began to feel serious doubts by the
end of the first term and the following vacation spent in Lon-
don. The lectures and classes held no problems, but with a
profusion of material to deal with I badly needed guidance.
Ridley blandly approved of everything I brought to him, but
even I could see that some of it held little significance. To go to
Blunden would, I felt, be very bad form.

Ridley did insist that I must present a true "thethith." The

only one I could come up with was the obvious fact that the tone of a journal's reviews of American books was largely controlled by the political allegiance of the individual periodical, such as *The Quarterly Review, The Edinburgh Review,* or *The Monthly Repository.* I pointed out that the situation was similar to the reactions of contemporary observers of Soviet Russia. That was observant of me, Ridley granted, but he was sure I would hit upon something stronger.

Though unwilling to take my problem to Blunden, I was able to do him a favor by trying to help a Korean student who had been referred to Blunden because of his Japanese connections. This man had been awarded a scholarship by his government in order to undertake advanced study at Oxford. Unfortunately, Blunden could scarcely understand his strongly accented English. This offered no problem to me, and I escorted him to the B.Litt. lectures. I could see early on that he was not equipped for research at Oxford, as Blunden had suspected. If an impasse can reach a climax, or, better, an anti-climax, this occurred during the course on the history of printing, illustrated with slides. Almost the first slide shown was one of an early Chinese text. The lecturer pointed out the ink lines evidencing the existence at this date of a variety of "moveable type." He then used his pointer to single out a character near the upper left corner, saying with false modesty that he "understood" it to mean such and such, whereas a character near the lower right margin meant so and so, as one might indeed guess from its constituent parts, for its "radical"—ahem—somewhat obviously meant this and that.

The only flaw in all this self-deprecating exposure of knowledge came from the misfortune of the slide's having been inserted not only upside down but in reverse. The Korean and I had reacted instantly, he with an audible intake of breath, I with a subdued "Oops!" When the error was not corrected the Korean made a move to put up his hand, but I stopped him. "Teacher lose face!" I said. Fortunately, he understood and I was also able to persuade him that we should not go up at the end of the hour to share our wisdom with the lecturer. The

Korean was clearly puzzled, but in the end Blunden and I were able to persuade him that instead of working for a degree he should turn his scholarship into a literally traveling one and survey methods of teaching English at various English and Continental universities.

If only my B.Litt. problems could have been solved this easily I might have been a relatively contented scholar. Though I was profoundly uninterested in the history of Anglo-Saxon studies, I took the required notes in Nichol Smith's lectures. In paleography I found that I had a natural gift for deciphering difficult hands of all periods, something I hadn't known, and I glibly read off at sight facsimiles handed out to our little band, much to the annoyance of the truly earnest members, some of whom by now could see an entire lifetime of research spent on their richly significant subjects.

C.S. Lewis instructed us in textual criticism and analysis. He was one of the few lecturers at Oxford in those years who drew an audience. He spoke clearly and with a fine personal flair for the dramatic. I had attended his lectures that were to become *The Allegory of Love.* Each hour ended climactically on the dot. I regretted one of Lewis's deletions when I bought a copy of the printed text. In his discussion of Spenser, Lewis built up to the fine contrast on pages 320 and 321 of the book as it now reads. He declaimed the contrasting summaries of the poet's qualities that he wished to leave with us:

> The first would run something like this:
> Elfin Spenser: Renaissance Spenser: voluptuous
> Spenser: courtly Spenser: Italianate Spenser:
> decorative Spenser.
> For the second I propose—
> English Spenser: Protestant Spenser: rustic Spenser:
> manly Spenser: churchwardenly Spenser: domestic
> Spenser: thrifty Spenser: honest Spenser.

And then, with a glance at the clock, he threw back his head, paused, and, with a broad smile, exclaimed: "In short, *Uncle* Spenser!"

No such spirit infused his B.Litt. classes. Lewis was known to be decidedly anti-American in his views, possibly in deliberate contrast to the recent conversion of Nichol Smith, who not only knew that Longfellow was an American but had been invited to spend a term as visiting fellow at the Huntington Library in San Marino. Reports of his activities in California vary, but at least four facts are agreed upon by former staff members. One: He had been taken by H.H. Davis (UT and Exeter '24) to a small rodeo in the San Gabriel Valley where he had been photographed wearing a ten-gallon hat that made him look more authentic than the most weathered cowpoke present. Two: He spent most of his hours at the Huntington itself reading the *Dictionary of National Biography* with great interest, somewhat to the staff's bemusement; for they did not consider it their rarest or most precious possession. Three: What research he did undertake was focused on the Forty-Niner song, "Clementine," and its trans-Pacific crossing to Australia. Four: To mark the close of his stay and to thank their hosts, he and Mrs. Nichol Smith threw a cocktail party in the public rooms of the Athenaeum at Cal Tech where they were staying, in direct, though probably unconscious, defiance of the house rules.

In contrast to Nichol Smith's acceptance of what he called "American methods," Lewis tended to query those of us whom he may well have considered ex-colonials with some asperity and disapproval.

My primary problem, however, continued to be the urbane M. Roy Ridley. I eventually came to realize that, like many persons inside and outside of the academic world, including myself, he hated to admit ignorance of any subject under discussion. He carried this to such an extreme, though, that he apparently knew things there was no reason to expect him to have any knowledge of. At first, Ridley struck me as astonishingly well read in American letters as well as the most obscure periodicals that I turned up at the British Museum Library. Later, after a few experiments, I came to realize that the most worthwhile return I could hope to obtain for my supervisorial

fees would be in the form of glass after glass of first-rate sherry. Every other Friday at six o'clock I floated out of Ridley's rooms a true "son of Belial, flown with insolence and wine."

I even managed to develop a largely specious thesis, which I do not care to elaborate upon. The only discoveries of significance that I made for myself were that in the nonconformist Midlands William Ellery Channing was considered to be probably the most important American writer of the age, and James Fenimore Cooper, whose works I had known exclusively through *The Leatherstocking Tales,* was a far more interesting and original writer than I had suspected. He raised pertinent questions about "national" literatures and the role of the writer in a burgeoning republic. My supervisor was always ahead of me with all of this and I could only wonder at what an acquiring mind could pick up on a motor trip to Kansas.

Late in the spring of 1938 I sat for the written B.Litt. examinations. During the same period a professional typist in London was copying my thesis.

In the course of writing on the history of Anglo-Saxon studies I committed the total error: I stated that a well-known codex was found a hundred years before it was discovered by a scholar who never saw it in a place it had never been. Waking at three in the morning a few days after the exams were over to the awareness of this horrendous howler, I wondered if there could be any point to showing up for the *viva.* After thinking over my options I knew I had no choice.

So show up I did in my B.A. gown and mortarboard, wearing a correct wing collar with white bow tie, my (rented) black silk hood lined with white fur slung over my shoulders.

I was told that my first examiner would be Mr. Denholm-Young, the lecturer who had conducted our course in paleography. As I approached the chair in front of him he rose, took off his mortarboard, and bowed. I took off my mortarboard and bowed in return with a lifting heart, hearing him say, "Mr. Espey, I have only one or two small questions to ask you; for you have in your paper maintained your usual standard of perfection." This was a dazzling honor. I knew I was not going

to be failed. I also knew that somewhere down the line I would be made to pay. I suspected that it would be under the questioning of Professor Nichol Smith.

In this I was mistaken. My second examiner was C.S. Lewis. Reading from my paper on textual analysis, he complained over what he called "the slovenly idiom" in a sentence in which I had, writing rapidly, used "due to" adverbially rather than adjectivally. I assured him that I understood the distinction, but foolishly added that this usage was becoming more and more common in America and might well become standard.

I can still hear the scornful tone in Lewis's voice as he asked, "Mr. Espey, if you were at a German university you would be expected to submit the result of your researches in the German tongue, would you not?"

A touchy point. I knew about French universities and I thought the same held true of German ones, but I wasn't sure. Was this a trap?

I heard myself saying, "Yes, sir."

"And if you were at a French university, Mr. Espey, you would be expected to do the same in the French tongue, would you not?"

Here I knew the answer. Any French university would accept a dissertation written in any modern Romance or Germanic language, including "American" English. Was Lewis truly so insular as not to know this? Of course he was.

I lied straight out, saying with suitable humility, "Yes, Mr. Lewis."

"Then let me remind you that you are at an *English* university."

"Yes, Mr. Lewis."

"Perhaps you would be good enough to compose a sentence in which 'due to' is used correctly?"

Ouch! Well, Mr. Lewis had no reason to know that I was a native of Shanghai who had spent his boyhood among the Christians. "Certainly, sir," I said, and after a moment or two I brought out, " 'When asked, he immediately paid the money due to his creditors.' "

Did I detect a suppressed rustle of mirth running along the other side of the table? Possibly, possibly not. In any event, an icy-voiced Lewis said, "That will be all, Mr. Espey."

"Thank you, sir," I said, and tipped my cap to him as I rose, a gesture that went unanswered.

How, I wondered, was Nichol Smith going to top Lewis's performance? When his turn came at the very end I kept reminding myself that I had, after all, been "capped" by Denholm-Young, though presumably humiliated (and forced to lie) by Lewis.

Nichol Smith cleared his throat, looked me full in the face with what on anyone else's features I would have called a leer, and said, "Mr. Espey, is there *one* thing you would care to say before I ask you *one* question?"

"Indeed there is, sir," I said, and went on to do my best to straighten out the inane confusion over the Anglo-Saxon codex.

When I had finished, Nichol Smith, with a vocal convulsion that I recognized as an extreme form of Scots laughter, nudged one of his neighbors in the ribs and said, his native accent so strong that it took me a second or two to understand that "point" was the word he was using, "A *small pint*, Mr. Espey, a *very small pint*—a mere century!"

And that was that. All the examiners, with one exception, broke into laughter. I had been passed.

A couple of days later I picked up my thesis in London and officially submitted it. Within the week I was informed that I would be able to defend it publicly about ten days later. My examiners would be Mr. E.C. Blunden and Mr. C.S. Lewis.

As to that examination, all I care to say is that Lewis questioned me for some thirty minutes with such art that his lips were never sullied by pronouncing the name of a single American writer, and that whatever damage I did myself during that first half hour was somehow repaired through Blunden's gently perceptive queries during the second. In the following week I learned that my thesis had been approved and that I could supplicate for the degree of B.Litt. to be conferred on the next degree day.

My Oxford years approached their end. How effective a representative of California I had been during those years I hesitate to say. Some of my fellow Americans had, I knew, resented my Shanghai-bred chameleon accent, not to mention my taste for velvet and tweed neckties and the white brass waterpipe and six-inch ivory cigarette holder I had brought with me from China. At the same time, I had made a number of lifelong English and Canadian and American friends.

By now I knew how impractically I had handled my academic life at Oxford, but I had no regrets. After all, I had arrived with no burning research interests; I had enjoyed perhaps the most unusual set of tutorials with Blunden that anyone had experienced; and I was leaving with what I believe was the first research degree in English granted by Oxford that had any connection with that suspect genre, "American Literature." O Pioneer!

Only one question remained. How had I been fortunate enough to get into Merton, the college that was almost always the first choice of anyone planning to read English?

A few days before I was to sail from Southampton for New York I found myself strolling with Idris Deane-Jones along the section of the old city wall that marks the southern limit of the Merton Garden. I had nothing to lose, so I put the question to him direct.

He brooded for a time and then said, "The most important thing was your knowing Blunden's name, knowing that he was Merton's tutor in English and wanting to work under him. Americans usually have no idea who the dons of any particular college are. And then, you know those little essays that Rhodes men are required to submit . . . "

"Oh dear!" I exclaimed.

Deane-Jones laughed. "Exactly. You are on the point of going down, so there's no harm in telling you that we look forward each year to the day the Rhodes applications arrive."

"I'd think they'd be a frightful bore," I said.

"Not at all. We get some splendid laughs out of them. It's unfair, of course, but you have no idea what claims are made.

As I recall, the point with yours was that you sounded quite human in your limitations."

"Ah," I said.

"There was another thing," he went on. "By now we've had some years of experience in dealing with Americans, and one thing we've learned is that for our particular system, the most adaptable Americans come most frequently from the South of your country."

"I can understand that," I said, "but . . . "

"Oh, you needn't explain," he interrupted. "I'm sure we recognized you as a potential Mertonian from the start, but if anything further was needed, it was the fact that you came from South California."

Compleat Mertonian that I now was, I said smoothly, "How lucky for me!"

"Quite," Deane-Jones answered, ending the matter. We went on to the inevitability of the coming war.

In silence I recited to myself Merton's Latin toast: *Stet fortuna domus!* Literally rendered it might go something like "May the prosperity of our house stand firm!" but it occurred to me that someone like Ezra Pound could angle it into "May the luck of the draw stay with me!"

By and large, it has.

Carolyn See, Ph.D.
(UCLA 1963)

The In-Crowd

A BRIGHT MORNING IN THE FALL OF 1958. The (Basement) English Reading Room in the new, brick-and-glass Humanities Building at UCLA—the University of California at Los Angeles—an institution of higher learning that has been in existence only since the beginning of this century, but that nonetheless aims to be "great."

Maybe two dozen young men and women—second-year graduate students in their middle twenties—drift into this basement one by one, slinking past an older woman named Grace who runs this brand-new sanctuary, monitors the study habits of graduate students who enter here, closely scans their silhouettes as they leave, watching for filched books. Grace keeps a tin box full of three-by-five cards that list the bad habits of each student—whether they smoke, whether they chew gum, whether they're Jewish.

The students here today, after a first year of very hard study, have been chosen as the new English teaching assistants, and by this, have become part of the larger plan. In this academy, so enormous, and still so new, the Department of English strives mightily for an identity and a reputation. Someday, it is hoped, the University of California in all its branches will defy and overcome the mighty East. Someday, geniuses—professors

71

and students alike—will choose UCLA over Yale, and not just because of the money or the weather.

To begin to make this happen, professors from all over the country and the world have been ferried in. Five years before, Helen Gardner came over from Oxford and taught hundreds of dumbstruck kids that no words on earth were more beautiful than those of T.S. Eliot or Gerard Manley Hopkins or John Donne; that pure joy lived in those words. But most of the time, now, the quest for greatness seems like something else. It's based on a strict hierarchy: full professors, associate professors, assistant professors, teaching assistants (male first, female second), students, women who hang out on the margin of things, and then, perhaps, the gardeners, who are bent on making the grounds of UCLA botanically great as well.

It works like this, in 1958. The old guard has tenure. They publish—when they do—for the sheer pleasure of it. They hold monthly poker parties and play pool in the brand new Faculty Center and one of them (everyone says) ships his shirts to London to be laundered. If UCLA is to become the major university everyone wants it to be, well, the elders will watch, encourage, threaten, intimidate, but they're not going to do the *work*, are you kidding?

They bring in bright young assistant professors for that, a new crop annually from the Ivy League. They've got six years to make tenure and contribute to the reputation of the school. During those six years, every wife of every assistant professor will lose her youth.

Under all that, floating the enterprise, the teaching assistants. Almost every one of the thousands of students who slog through these bare new halls (ceilinged with bars of blue-white fluorescent light) will have to take a class in Freshman Comp., and half of them follow that up with a semester of Freshman Lit. Who will teach those classes, assign those papers, wrangle over grading standards, fend off the maniacs who hand out messages to their fearful instructors: "The Eagle never lost so much time as when he submitted to learn from the Crow"? It's not going to be those natty old guys with the perfect shirts and

the personalized pool cues. And it's not going to be those hordes of old-young men straight from the Hamptons who hustle up and down the halls in seersucker suits. They're frantic, revising their doctoral dissertations, sending them out to good university presses, giving parties and going to them. They measure their academic success so far by whether Professor Leon Howard—lately in from Northwestern, authority on Herman Melville and the "Coat Hanger Theory of American Literature"—gives them a piece of meat when they come over for dinner, or whether he makes them eat a big mountain of rice and peanuts and nothing else; no chutney, no parsley, no cayenne, no—

So you can see those guys can't be bothered with Freshman Comp. They'd freak, they'd fall down, they'd go crazy—like one promising poet-professor *did*, actually—or they'd flee in the middle of the semester like that man from New York who called in sick one day, and when Dorothy, Queen of the Secretaries, took him some soup, the door to his apartment was open, his clothes were gone. The landlady was running the vacuum. He couldn't take it; he left.

We don't know any of this yet. We don't even know each other; we only know that we've applied and that we've been accepted. We're going to get $160.00 a month for teaching a class, teaching a class! What we've wanted to do for so long. There are those who say it will help us with our Ph.D.s, this teaching experience; that it will be easier for us to get a job later. But there are also those who say we shouldn't sully our scholarship with teaching—that we'll get sidetracked, that it will be *harder* for us to get our degrees. There are also those who say that we have no business even thinking about a degree before we're forty, that a Ph.D. should mark the high point of an academic career, not the beginning. But we know we can't wait until we're forty because we have to get our degrees in under seven years or we're out, absolutely out, with no redress, and we've already started, so that's that. We have no more than four, no less than two years before we must take the "First" or "Master's" or "Qualifying" exams. Only 50 percent of us, at

the most, will make it. If we pass the Qualifyings, it's two more years of studying our specialties, a second Qualifying exam, throw in two reading exams in two different foreign languages, two to three years for our dissertations, "an original piece of scholarship." You see our fix.

The chair of the English Department calls us to order. "Now," he says kindly, "you will finally have the chance to pass on some of what you have learned."

The quaking strangers in the Basement Reading Room were fools for learning. They wanted to know—they thought—about the Romantics (or was it romance?). About Shakespeare's plays (or was it playing?). About Tragedy (or did they crave their own disasters?). What they were, what they were, was lonely. What they wanted, more than learning, was friends. What they needed was a ticket to a better life.

The strangers there that day included: A shy red-headed Irishman named Tom Mauch, whose dissertation would turn out to be a monumental work on the Renaissance Proverb. Charles and Bonnie Culotta, who lived with Mr. Mauch as semi-caretakers of a "Spanish" mansion in Brentwood made of genuine adobe. (Its wealthy owners, Harry and Olivia Johnson, referred to it affectionately as the Casa de Mud.) Tom Sturak, a tough guy. Sidney Richman, a funny guy. Bob Newman, who stubbornly pursued the eighteenth-century concept of the Sublime. Herb Newman, a funny guy who would not make it through. Scholarly Stan Stewart, who, as a kid, had rolled his cigarette packages in his tee-shirt sleeve. Paul Frizler, giddy and sweet, whose golden wife, Sheri, was putting him through. Doug Scott, whose life would be a firecracker series of misses and hits, and who had a constant yearning for the Larger Life. Judy Wilson Hurst, who valued friendship and adventure equally. Judy was the only one who spoke to me that morning. She sidled up and whispered sardonically, "It looks like we're finally in with the In-Crowd!" But, of course, we were still strangers, and would remain so for weeks.

Yearning strangers: Shy Tom Mauch, Charles and Bonnie

Culotta, Tough Tom Sturak, Funny Sidney Richman, Sublime Bob Newman, The Unregenerate Herb. Scholarly, smoking Stan Stewart. Paul and Sheri, our Golden Couple. Doug "Larger Life" Scott. Judy, my best friend for twenty years. And me. It is a teaching tool to repeat names.

What we would teach would be that dreaded Freshman Comp. What we were expected to learn was considerably more complex. During the first two years of graduate school, the English department required from four to six graduate survey courses: Bibliography, Medievalism, the Renaissance, the Seventeenth Century, the Eighteenth Century, Victorianism (with a reading list as long as a book), Contemporary British, American Lit., divided into halves. You had to know all of it. You had to have passed, before your first Qualifyings, your first language exam, in which you prepared fifty pages of some foreign critic and then sight-translated other lines under the watchful eye of a cold-hearted witch. You had to have taken three semesters of our own language: Old English, Middle English, Modern Linguistics. You had to have taken two "advanced seminars" in something special: Modern Poetry or Transformational Syntax or whatever might prove to be in your field of interest.

By the time we stood shyly apart from each other in the English Reading Room, we had skittered our way through one year of all that. We had puzzled, in stress-filled, anonymous graduate surveys, through the verses of Anne Bradstreet: "Be still thou still unregenerate part / Disturb no more my settled heart. . . . " Had shuddered silently, as Ralph Waldo Emerson droned: "I, Alphonso, live and learn / seeing Nature go astern / things deteriorate in kind / Lemons run to leaves and rind / Meagre crops of figs and limes / Shorter days and harder times." We had heard one professor explain that, in his particular century, the population was neatly divided into people who thought everything in the world was getting bigger, and those who thought everything in the world was getting smaller. Had heard in another that we should always think of

England as bread, because the middle class was always rising. Had all been in for our interviews with the woman in charge of the language exams—who, I see now, must have been a poor, demented creature. And in Old English, in despair, we had been introduced to the Great Vowel Shift.

We? There wasn't any "we" in the first nine months. All I knew was: I was in the fourth year of a marriage to Richard See, an almost-Eurasian, and graduate student at UCLA in Anthropology. We had a beautiful three-year-old girl named Lisa. We managed a thirty-six unit tenement, the Sentous Apartments—in L.A.'s "second skid row"—that we waggishly referred to as "the prestige apartment of the neighborhood." (Our first morning in the Sentous hell-pit, we had found a note on our door: *Dear Mgr. I still have the bugs in bed.*)

Every day, during the first year, I went alone to classes where I didn't understand a thing, drove home with my tired husband, picked up our daughter from the Salvation Army Nursery School, stopped by the store to buy rice, meat, salad greens. We ate. Did the dishes. Took turns reading Lisa a story. From eight to eleven at night we studied. The phone never rang. We were stuck in this crazy existence and it was as far away from our vision of academic life—green lawns, kind mentors, great friends—as it was possible to be.

I could read a passage like: "What then should I liken the sperm whale to for fragrance, considering his magnitude? Must it not be to that famous elephant, with jeweled tusks, and redolent with myrrh, which was led out of an Indian town to do honor to Alexander the Great?" I could read that, as I say, and feel nothing but grief.

My first semester as a T.A. I typed only index cards, but in the spring of 1959 I stood in front of my first class. Pink shirt from Brooks Brothers; tweed skirt. "You see," I quavered, "you've got to *be specific!* Like. . . . " Here I teetered toward a window on my medium-high heels. "You don't want to be calling this just a *wall*, because there's more here than just that general description, *wall*." A class of thirty disaffected teen-agers, all of them richer, smarter, prettier than I, stared at me.

They couldn't test out of Freshman Comp; they (and I) were stuck in here for fifteen weeks.

"Like...." My voice trembled. Some guys laughed in the back.

"There's like, you know, the *windows,* and then there's the window *sashes....*" My clammy hands held on to them, hoping for support. "And right here in the middle of the window sash is this thing, I don't even know the name of it, do you?" No they didn't, and they didn't care. But they knew what was coming next, and watched with an awful interest.

"And what's the smallest, in a sense, the most *specific* thing you can see in all this wall?" I knew then what I had to say, and it was still the year 1959, and there wasn't a *way* I was going to get out of it: "It's a *screw,* don't you see?"

A voice said, "I knew she was going to say that."

Another voice answered, "I knew it too."

.There were still another forty minutes to go in that hour. And forty-four more meetings of that class.

Still strangers, the new T.A.s met once a week, to talk about how we were teaching Freshman Comp. One young man seemed so *on top* of it! He shared his enthusiasm about Virginia Woolf: "Just take a look at this essay!" he announced, waving a copy of *The Common Reader.* "You couldn't take a word from this essay without changing it utterly, irrevocably, and forever!" The T.A.s who had already taken Nineteenth-Century Literature must have known this confident young man was parroting the Oliver Goldsmith essay that said, *ironically,* if you took a shilling from a thousand pounds, it was a thousand pounds no longer. But not one of us, then, had the nerve to speak up. The phrase for us then was *"out of it."*

In the late fall of 1959, Tough Tom Sturak stuck his head in the door of my office, and everything I learned from then on meant something. In the course of a few months I learned that when Shy Tom Mauch ran out of gas on Sunset Boulevard, he called up his fellow caretaker in the Johnson House Adobe, Charles "the Count" Culotta (so old, even then, that he was rumored to have been at Pearl Harbor as a soldier on the day

the Japs flew over). Charles came to the rescue, wearing a Nazi Storm Trooper's helmet and directed traffic on that crowded thoroughfare, officiously.

I learned that Charles was so hard on his wife, Bonnie, that once when she bent a fender on their old car, he picked up a kitchen chair and hurled it with all his strength at the ceiling, so that a lot of the grand old Johnson Adobe fell down on the floor around them. And, when Bonnie and Charles worked summer jobs as forest rangers, Bonnie went out for a walk once and got lost in the bush. When she made it to a ranger station she asked, "Has my husband reported me missing?" They, of course, said no. (Another version: He *did* report her missing, and the forest rangers *shaved* before they went out looking for her.) Charles went out for a walk of his own. Bonnie waited, with dark thoughts, stacking a summer's worth of canned goods up around her. When Charles returned and began the long, four-sided climb up that ranger tower, she hurled all those cans, as Charles howled, plaintive now *"Bonnie!"* His beautiful, long-suffering wife came away from that day with another name, "The Bash."

Tom Sturak—ex-navy man, obsessed with existentialism and Mexican music—camped out with his old surfing buddy, Jim Andrews, and a failing writer named Cody—who survived solely on a diet of lentils—at the home of Jim's movie star uncle, Dana. Uncle Dana came home once and wanted to take a shower. He found Tom Sturak there first, stark naked; dripping, but urbane.

"Howzit going?" the star of the American cinematic classic *The Best Years of Our Lives* asked the total stranger. Sturak, equally civil, answered, "Just fine, sir."

Judy Wilson Hurst had left that husband named Hurst, blown in from Idaho, where, she liked to remark, she had never encountered either Jew or Anchovy. When she came to California, she would enthusiastically espouse the one, discard the other. She had a little daughter whose bed was a chair—thank God, an *easy* chair. . . .

In class, we learned about James Fenimore Cooper. We sat

dazed, in Advanced Linguistics, as Noam Chomsky sent in bulletins on hazy mimeographed sheets about transformational syntax and his theoretical, invisible box that could generate an infinite number of sentences. We learned that a five-year-old could also generate an infinite number of sentences (as if any Depression housewife in any seedy California bungalow trapped with a room full of toddlers couldn't have told that to Noam in the first place!). We learned that in some parts of the American South when the natives pronounced the word "badger" they gave the "a" sound three separate vowel sounds. And we must have learned Hell's own amount about Wordsworth and Coleridge, but all I came away with was a memory of that professor's silvery head of hair, and that he always lectured sitting down. Jimmy Phillips, splendid professor, spoke to us of Shakespeare. The words, so ineffable and swell, sank like stones into our brains.

After a while it might have dawned on us that we were assimilating culture in binary chunks. We were being presented with two in-crowds, two sets of learning. There was that first in-crowd, a complicated social system going on in many rooms: Milton and Shakespeare. Melville and Hawthorne and Emerson and Thoreau. The great party going on over in the Bloomsbury room: Virginia, married to Leonard; Vita, who ran off with Violette; Vanessa, married to Clive; Morgan, who loved his sweet policeman; Lytton, who once proposed to Virginia but reneged the very next day. Duncan Grant, who slept with them all and out-lived them all: they were the in-crowd closest to us in time and space. But what had they, and their refined ways, to do with a desert beach city, swollen with war money, on the California coast? The Bloomsbury people, though they lived in a way we envied, would never have let any one of us into their homes.

We began, hesitantly, to make our own in-crowd: Tom Mauch, the shy one, who lived with Wild Charles and Beautiful Bonnie in that mythic adobe mansion with the sophisticated couple who showed us how to be rich; Tough Tom Sturak, who

was sweating out a divorce and currently in love with a blonde Latvian refugee who lived in Tijuana (thus our frequent Mexican trips in the early days; our attendance at bullfights, our bright nights at the Foreign Club). We made our golden couple Paul and Sheri; she a bank teller who got robbed so many times by the same man that she once impudently queried him, "*You* again?" as he sheepishly displayed his gun. Scholarly Stan Stewart, who got married and had a kid without even telling us. Judy Wilson Hurst, who showed by her every move in life that life could matter; whether you were talking mathematics, mayonnaise, you name it. Doug Scott, who kept track of Larger Life and became personally incensed at the incompetence of the Secret Service who let President John Kennedy die. When Lyndon Johnson came to speak at UCLA, Doug pinned a fake gold insignia in his lapel and jabbered into a fake walkie-talkie so successfully that he got into the Green Room afterward where Johnson wound down from his speech. Doug gave Lady Bird a big hug (she called him a sweet boy), then went home to write a paper about it, which he sent to the RAND Corporation, where it was promptly thrown out. Herb Newman, who couldn't answer a question about Henry James's failed London plays, flunked out of the program, married a beautiful wife, and went on to make a lot of money. And me, Carolyn, married to Richard, poor as stones, living down in the slums. We scarcely existed yet, coming from obscure families with little money and less culture, going to a school where overhead lights turned you turquoise and the paint was barely dry. But we were swimming as hard as we could.

What is comparatively easy to see now is that the university itself was in a quandary, just beginning to create its own legend: What was appropriate to teach? What was a real education? Sure, they had their atom smasher, they had their cinema department, but beyond that, what?

Our Old English professor, Will Matthews, himself a cockney who had made his name by sheer density of learning, would correct us as we struggled through translations of that

dead-and-buried language: "and strode through the bone-groves, the troop full of . . . " "Not 'troop,' " Will Matthews would say absently. "I think you'll find that 'patrol' works better." Silence, while the class covertly eyed each other. That *word*, whatever the hell it meant, translated out to "troop" in the glossary at the back of the text. But who would have the nerve to point that out? None of the guys; certainly none of the ladies, who seemed to be carried off regularly with nervous breakdowns, or that more civilized escape, marriage. . . .

Tough Tom Sturak was raised by a family so fierce that on one memorable Christmas Eve his uncle shot and killed his aunt. Shy Tom Mauch's Irish mother cared about cleanliness above all else, but was so hazy on technology that she once vacuumed up a bucket of water. Scholarly Stan Stewart's parents had locked him in dark closets when he was a kid. All these young men had come from family lives that might (charitably) be called unevolved. . . .

For close to twenty years, Judy Hurst was my best friend: we spoke on the phone several times a day, our children played together, she made fake bear rugs for them to loll on; we went trick-or-treating with those same kids, ate turkey sandwiches the day after Thanksgiving, hauled our toddlers out to department stores to buy Christmas ornaments and presents. I never met her mother; I never met her father. And as she visited my various homes, though Judy may have met my father, she never met my mom, so far did we try to displace ourselves from our unsatisfactory pasts.

When Judy married Mr. Hurst, he took her camping on her honeymoon; it rained. That and other things broke up her first marriage, sent her to Los Angeles, where she made up that bed for her daughter in the chair and went, alone, to school. She learned, rapidly, that high thoughts weren't enough: kids need beds. After a short romance with Bob Newman, the man who needed so badly to know all of literature, Judy gave him some kind of ultimatum: let's move in together or else! Mr. Newman demurred. What, indeed, did *he* know about life? His mother washed every can, every fruit, every vegetable, with hot soapy

water as soon as it came out of the grocery bag, and before it went on the shelves. Did he want *another* woman in his life? Not yet. One bright morning at the beach, Judy sat beside me, planning and ranting: If Bob wouldn't come through for her she'd find someone who would. Within the week, she did. (And created another story.)

Again, that's why all of us had such trouble remembering which lines belonged to Lord Byron and which to Shelley. We were there to learn, but not that. When Nathaniel Hawthorne and his wife scratched their names with her diamond ring in the window panes of their new home, we deduced that must be love: love was the knowledge we craved. When Dr. Holmes opened champagne in that New England cave during a sudden thunderstorm to celebrate the beginning of American literature, we figured that friendship and euphoria might be the categorical opposite of scrubbing a vegetable soup can with hot soapy water. When Hieronimo went mad again, we compared him favorably to Tom Sturak's Uncle Frank.

The young men who went to the English department of that raw new school wanted to learn to be gentlemen, to escape their peasant destiny. The women—years before Betty Friedan—had realized that having children, and fielding the blows (physical or emotional) of clueless husbands, were not acceptable life goals.

We read "This Lime Tree Bower My Prison," and sighed. We saw pictures of Virginia and Leonard and all their Bloomsbury cousins and cronies dressed up as Abyssinians, as part of an elaborate hoax, and sighed again. And while we searched for a way out of our really quite terrible isolation and poverty, in thick anthologies with thin pages and fine print, we noticed two men on the faculty who gave us some actual pointers on what we longed to know.

One, Leon Howard, was distinguished, world-renowned, all that. Leon Howard opened the doors of his home not just to assistant professors, but to frightened graduate students, fed them gin gimlets until they were dizzy, and talked in a mono-

logue about people none of us had ever heard of. (Just as I do here.) In his insistence that we should know, care, and *get it* when he spoke of Daniel or Duane or Dot, he taught us that indeed there was a Larger World. He knew quite a few of the people in it, and if we worked hard, we could too.

And, teaching advanced seminars, there was a handsome, asthmatic professor, John Espey. Students killed to get into his classes. He had studied at Oxford as a Rhodes Scholar, he had visited Ezra Pound after that poor poet was released from Saint Elizabeth's, where he'd been incarcerated as a treasonous nut. Espey's act was to know all without *telling:* he pantomimed a pleasing ignorance so successfully that, after he'd assured me (during a terrifying office appointment), even though he'd been born and raised in China, he knew no other Chinese words than *Ay-yah!,* I forgot my fear enough to blurt, "You don't know any more than that? Why *I* even know more than that!" Then, triumphantly, he showered me in a fifteen-minute flood of a tonal *Wu* dialect. In class, Espey alternated between explications of the Pound *Cantos* no one could understand, and—in an attempt to interest us in Yeats's concern with auras—tales of his own crazy aunt Clara who, on being told that her soul did better in yellow, wrapped herself each evening in a bolt of yellow satin—pinning it first to one post of a four-poster bed, swirling herself up in that same satin, unhooking the fasteners with her teeth, then hurling herself over onto her mattress like a glistening yellow caterpillar for the rest of the night.

Could a distinguished adult really make a living retailing such stuff? Could Espey's narrative of making Christmas dinner all alone, locked in his kitchen with nothing but a quart of vodka and a capon, be a ticket to respectability and the actual good life? Espey had published in *The New Yorker*— charming tales of revolutionary China, entertainment cloaked in erudition. The secretary of the department once told me, about the faculty, "Of course, they all have their specialties, but if you really want to find out something, ask Espey." You left his three-hour seminars feeling light-headed and strange, hyperventilated from having laughed so hard.

■

After my office mate got married and left, carrying a saucepan, I drew a new office mate named Larry, who—so much had things changed—opined that it was too *noisy* in the cubicle we shared, and could I keep it down a little? I took umbrage and after that spent most of my daylight hours down the hall with Tom Sturak and Bob Newman.

By the end of our first year as teaching assistants, we all had projects: again, dual in nature. We were preparing for our first set of Qualifying exams and a two-hour oral, which, if we all passed, would qualify us to go on for our Ph.D.s. And we were planning our first evening of charades: In homage to the eighteenth century "University Wits," we would be the University Half-Wits. In the home of Leon Howard, the living room packed with hundreds of undergraduates, Doug Scott recited beautifully bogus poetry: "What if the crystal you / Devoured the Christmas me / An equinox of rendezvous / Decries our Merest Mummery / Ah, no, my Tender Asp! / Ah no, my vichyssoise! / Your Cleopatra's asp / Has pierced my attic vase ('Vahz')." Scholarly Stan Stewart played an unlettered clod named Noble Barnes, Bob Newman translated hilariously from the Swabish, Tom Sturak scribbled Old English in the manner of our learned Old English professor; I, in a huge blonde wig and drunken, sappy smile, played Patty Pream, the quintessential pretty girl we all feared because she never had to work to make it. The evening was a huge success.

Paul Frizler owned a camera and had always wanted to make films. We all knew how hard we were working for our degrees; it seemed like a crazy rat race! Tom Sturak was a runner—to the scandal of his peers. Why not make a movie: *Run for Your Ph.D.?*

Low on plot, even lower on cinematic values, *Run for Your Ph.D.* became our Bloomsbury African hoax. Tom Sturak and Tom Mauch, Sheri Frizler and Carolyn See, dressed in identical costumes, worked hard for that elusive academic grail, ran for their Ph.D. They drove identical black Volkswagen bugs, and at one memorable moment, recited in four-part unison, as

their cars pulled up against a cement bulwark, "It looks like we've run up against a blank wall!" My daughter Lisa, then four years old, panhandled in Venice to pantomime poverty. Bob Newman halted his pursuit of the Eighteenth Century Sublime long enough to play "Chairman of the Department." He sneered and snarled and engaged in a badly staged car chase, intent on murdering his students to keep them from their degrees. Sturak nimbly danced away. He *would* get his Ph.D.! So would we all.

From there it was just a step to our next film noir, *Nous Sommes Tous des Monstres,* or "We are all some Monsters," filmed on location at the Johnson Adobe, "Casa de Mud." Mrs. Johnson grew asters as big as dinner plates and was the president of the Brentwood Garden Club. Mr. Johnson, retired petroleum geologist, was fond of muscatel. D.H. Lawrence had visited the Johnsons in the twenties and chided them for "playing their days away," but they went right on doing that, serving drinks each evening in front of a roaring fire, eating perfectly cooked dinners, making conversation that sounded like sterling silver bracelets, and—in the sweetest possible gesture—lending us their house as a set. While Charles Culotta made his contribution by replanting beds of dead snapdragons that the gardener had already pulled out—because Charles liked the look—the rest of us worked on the movie.

Nous Sommes Tous des Monstres involved a mysterious stucco mansion and the Johnsons' chest of costumes. Bonnie "The Bash" Culotta played a mean lady who killed people by putting them through the mangle. *"Put them through the mangle!"* Doug Scott played a private eye, with verve. Charles Culotta pulled a string of plastic ducks through several scenes, because he wanted to. Still technically imperfect, *Nous Sommes Tous des Monstres* was far ahead of *Run for Your Ph.D.* where, to show a house burning down we had been forced to burn a shoebox in a bathtub.

We had begun to realize that Beowulf, Byron, Cather, Cooper, Thackeray, Thoreau, were not where it was *at* for us.

There were those on the faculty who deplored the glitch that

had let this particular generation of students in. For one thing, we might not be the stuff of a great University. As Patty Pream at the first charade, I had looked out from under my wig and seen an assistant professor staring at us with disgusted incomprehension: Berlin is in crisis, his look said, louder than words. Laos is overtaken. The U2 plane, with Francis Gary Powers in it, has been shot down. The fate of the whole world hangs in the balance. And you, all of you, do dumb imitations of professors with amusing tics and students who can't master their homework?

He had a point. After the U2 incident in May of 1960, and Khrushchev banging his shoe at the U.N., there came a time— as we stood about casually in the living room of the Johnson house, waiting for the next shot of "Monsters" to be set up— that Judy Hurst again sidled up to me: "Guess what? Drew Pearson said in his column this morning that nuclear war is inevitable by next October." It must have been June by then. We were staying up to midnight every night reading Dryden and Pope, Johnson and Bacon, dreaming Old English verbs in our sleep, learning to cook, beginning more and more to "have people over." We were smart enough to know that if Drew Pearson was right, our Dear World would end in the summer or fall of 1960, before the Russians would even get to build their stupid Berlin *Wall* the following year. There was nothing at all in the "real" world that we could do about it. In the worlds we'd studied there was nothing they could do about it either. Hemingway had declared a separate peace in World War I; declared a better war on abstract nouns. Virginia Woolf, in World War II, had put rocks in her pockets and waded into the muddy River Ouze.

We took our cue from the citizens of London, who, during the Great Plague, danced. By then, for better or worse, we had each other. And although we knew that Marvell was just putting the moves on some nice girl when he wrote "Let us roll all our Strength, and all/Our sweetness, up into one Ball," we must have thought we could do that same thing by staying together and having a party.

In the summer of 1960, we began to dance. Paul Frizler combed his hair like U.S. Bonds and wore the paper cover of one of Bonds' "forty-five" records pinned to his chest so that we could not fail to notice his accomplishment: "School is out at lass'/and I so glad I pass!" We partied night after night. One couple repaired to a shower stall fifteen minutes after they met, and began a romance none of us would forget. Every night we stayed up together, eight to a dozen of us, watching television until the test pattern, then falling asleep in our chairs.

At nine or ten every morning, as we went outside to forage for sweet rolls, we'd see on the newsstands that the U.S. or Russia (or even *China*, for God's sake!) was predicting the end of the world by the end of the summer, unless the rest of the world buckled under and did what (respectively) the U.S. or Russia or China wanted. "How vainly did themselves amaze / to win the Palm, the Oke, or Bayes!" But those boys hadn't read Marvell.

That summer, other people built fall-out shelters. We made tacos until our tiny kitchens filled with smoke. At someone's house, Judy and I watched with disgust as all our own darling guys chased after a woman of forty! We played our music so loud, through our fear—of loneliness, of flunking, of death— that the cops came. We fell in love with each other again and again.

Tom Sturak and I were, by that time, living together in a small frame house in Manhattan Beach. I knew, *was sure of it,* that we were going to die very soon, in World War III, just as Drew Pearson had predicted. One swell night, we talked and ate and danced and drank and played Mexican music until, again, looking outside, we saw that it was dawn. We had to get some sleep for our party the next night, but we thought we should walk down to the water. It was gray, still, a little raw. We heard behind us, a wife complaining to her husband in low tones, "I never know what to wear at these things! Why don't you ever tell me what to wear!" Because, by then, we were the In-Crowd. *We* knew what to wear. How to dance. How to read. And, because of Charles Culotta rescuing Shy Tom in a Ger-

man helmet, or Naked Tom with the movie star, or Sheri's bank robberies, or Judy's Jews-and-Anchovies, we knew what made up a story and how to tell it. The great gray neutral ocean in front of all of us, bigger than any Palm or Oak or Bayes or Bomb, seemed, in waves, to smile.

Advanced Degrees

URING MY FIRST YEAR AS A TEACHING
assistant at UCLA, Professor Robert Stockwell taught
the graduate class in Middle English every Monday, Wednes-
day, Friday. It was a ghastly experience—partly because most
of the class had not yet taken Old English, and floundered
badly; partly because it seemed that two-thirds of the class
knew no one and sat in terrible, friendless isolation; partly
because the other third knew each other very well, and made a
big deal out of that. The professor himself was interested only
in Transformational Syntax, and more than one time there
floated through the air a feeling that—as we churned through a
brand new Middle English textbook—the professor was no
more than ten pages ahead of us.

That term UCLA seemed as impenetrable as a medieval
fortress. My husband Richard would drive me to the border of
the campus, let me off, then drive off to find a parking place,
sometimes literally miles away. Then he would trudge back
and do his own work in aboriginal dialect. I would make it
just in time for Middle English, having done my translation in
the car. I sat four rows in from the window and three seats
back, having chosen a seat where I could be seen, but be a little
too far away to be called on. The whole trick was *not* to be
called on, because first you had to read the passage in question

aloud in Middle English, and then translate it out, and it was devilishly tricky stuff. Beyond that, I was too afraid to raise my voice above a whisper. More than once, after an in-class humiliation, I went across the hall to the ladies' room, to cry.

In Middle English people went mad, quietly. There was a man who wrote a forty-page paper for a two-page assignment; his face contorted as he tried to defend himself: you couldn't even *approach* the subject in fewer than forty pages. A nice girl named Carolyn, like me, dropped out of the class and out of school. A nervous breakdown.

But around me, I could see that some other students didn't have it all that bad. What *was* it, that they didn't take it "seriously," that they had another life? Every morning, seconds before the final bell, two handsome young men sauntered in, heads inclined together, bantering? Muttering? Doing something just this side of snickering? You knew them by their suits as much as their good looks.

Sidney Richman, always in the middle of a joke. Didn't he know these were our *lives,* here, hanging in the balance? Tom Sturak, slight of build, all angular cheek bones, wearing a different suit every day for two weeks in a row. Sturak was like a lean William Bendix (and later Tom would speak fondly of that crass character actor, exhorting new recruits in the Korean War from ancient black-and-white documentaries, to go out and "Smash Dem Japs!"). When other students cringed as Stockwell got down to the business of translating, Sturak would wave one hand carelessly in the air: "If you, uh, want to do something about these *typos,*" he'd suggest, just this side of sneering, and because it was a spanking new text and Stockwell knew the author, twelve to fifteen minutes would be taken up at the beginning of each hour while Sturak changed semicolons to colons and Stockwell eagerly penciled in corrections.

How could these young men be so intensely fearless? How could they speak up like that? My husband, Richard, was so bashful he often went without coffee altogether rather than flag down a waitress. *These* men jabbered! They'd been servicemen (Sidney Richman in Germany, Tom Sturak on a Pacific air-

craft carrier) but no, they had never seen combat. So how did they get that way? It was just a fluke—a side of life I had never seen, and had I not gone to UCLA might never have seen—men as brash and impervious as new fluorescent lights.

Tom Sturak's neck was pink. Sitting behind him, as I some-times did, I saw that; saw his starched shirt collar above his jacket, mused about his golden Nazi hair, clipped close as fuzz. (Richard had dark hair down past his collar, and a Mandarin beard.) Sturak was *slight*. Once, a student who didn't like him much whispered to me out of the pure blue, "You could snap that guy's wrists with one hand," but I couldn't answer. I was too scared. Because I didn't know that man (now safely tenured and respected in a Florida university) either.

I was all alone, always either on the verge of tears or in them. Once, when I first began to teach, I tried ineptly—during my office hour—to explain to a student of my own the difference between a "ball" as you held one in your hand, and the letters, B, A, L, L, and how they added up to a symbol for that actuality. "Do you see what I mean?" I asked finally. "No," she wailed, burst into tears, and I did too. Then, horribly, she left me alone in my office where, coming in far-off waves, I could hear the laughter of the others.

One early afternoon in October, Tom Sturak appeared, lounging, half-in, half-out of my office door. I got up from my desk and stepped toward him. "Hey," he said, and held out a careless hand, "can you fix this stapler?"

I took it from him. We went up to the English office to see about getting another stapler, because this one was surely broken. We walked from the Humanities Building around the east side of fake Romanesque Royce Hall, and across the sedate patch of lawn between it and the fake Romanesque library.

It was a raw, bright California-autumn afternoon, sun shin-ing ferociously, wind blowing. I shivered; I was cold; I didn't own a coat. I wore black tights, a black sweater someone had stolen for me in high school, a lavender wool skirt. My hair was blond, I wore bangs, and kept the rest back in a school-teacherly knot. We couldn't find the books we needed at the

library and walked back to my office. Tom Sturak came in and sat down. It was Richard's night-class night; I had been going to study Middle English in my office. But some of the T.A.s were going into Westwood for dinner: would I like to come?

I was broke but Tom Sturak bought me a beer. The club we went to was narrow and two-storied; something was going on along the second floor, indoor balcony. Were they singing in German? "No, *Latin*, dummy! *Gaudeamus Igitur*. It's about professors," Tom Sturak said, quite incorrectly, "and how we should praise them because they're always gonna be young." I met Sturak's office mate, Bob Newman, a nice guy, and Paul Frizler, along with his wife, Sheri. All the people I'd seen around, it seemed, were here. Was it because I was married that I hadn't known how they lived, where they *went* after class? No, not just that. I'd been too scared, too struck dumb with the sad destiny of it all: a husband, a kid, and all your Thanksgivings sewn up for the next fifty years. But that night was pink and gold and new and young and that's not the half.

That Christmas I bought a half-price electric blue silk dress. At a teaching assistants' party at Dana Andrews' borrowed estate, I watched Tom Sturak's ex-wife's best friend pile up stuffed eggs. A flock of poor graduate students lined up on movie star couches and watched an athletic, synthetic fire. *New, new, new, new!*

Richard cried as he swerved drunkenly home that night. *"You love him!"* he sobbed, but my conscience was totally clear. And Richard was always a negative drunk.

We all pulled A's in Middle English and found ourselves, in that spring semester, in the perfect class, in the perfect time-slot: 10 A.M. Monday, Wednesday, Friday, the Poetry and Prose of the Seventeenth Century, Professor H.T. Swedenberg, Jr., conducting.

On the west side of the Humanities Building now stands a cement parking lot that reaches a depth of five levels, but then there was only a shallow grassy slope, fragrant with yellow flowers. Life was so pleasant, and this poetry at first so dense that it seemed natural, agreeable, inevitable, that Paul Frizler,

Tom Sturak, and I should stroll out there after class and w[
on those poems. We each had our heavy anthologies; but I used
Helen Gardner's perfect collection of the metaphysical poets, a
Penguin paperback decorated by a design of black vines en-
twined against a background of deep peach, and inscribed—
anonymously—in pencil, *"No quiero decir, por hombre, las
cosas que ella me dijo. La luz del entendimiento, me hace ser
muy comedio—aunque tú me has dicho nada."* I'd found the
book in my teaching assistant's postbox in the very first week of
the semester.

Winters and summers mix in Southern California. Janu-
aries, Februaries can be hot. In warm sun we'd recline in lush
grass. Paul Frizler would crash down like centrifugal force
gone mad, books and papers flying: "I struck the board and
cried no more!" he'd cry out, and lie down with a happy sigh.
He *loved* George Herbert but didn't know why. Maybe he
really needed to know about the connection between choler
and the clerical collar, about anger at the restrictions of life and
how finally you have to knuckle under: "But as I rav'd and
grew more fierce and wilde / ... Me thoughts I heard one
calling, *Child!* / And I reply'd, *My Lord.*"

What elegance! What beauty! What luxury, what promise!
My own favorite—then and now—was Henry Vaughan. Who
knows what kind of nut, what kind of blissed-out, blessed and
sainted soul, could, in the midst of gray and crowded, stinking
England, write down with such serene confidence, "I saw Eter-
nity the other night/like a great *Ring* of pure and endless
light/All calm, as it was bright. . . . " And even in the midst of
mourning, how could Henry have such confidence in a perfect,
better world: "They are all gone into the world of light!/
And I alone sit lingering there; their very memory is fair and
bright. . . . "

How did he know that, back in the seventeenth century?
Certainly our professor didn't dwell on these matters in our
sunny classroom: He wanted only to be sure that we were
conversant with the material. Once, when Tom Sturak, cor-
nered into talking (no typos to fall back on in this luminous

93

maze), hazarded that one of Donne's elegies was about "a debate between body and soul," Professor Swedenberg burst into delighted Southern laughter: "It's about two men in a *bookstore,* Mr. Sturak!" But no one took it too seriously. Yes, our Qualifying exams were coming up in no more than four months, our fates as academics would then be decided, blah, blah, blah, but we all knew each other by now, and my penciled note to myself in the back of the Helen Gardner collection of metaphysical poets still reads: "Letter to Daddy / *Un* corrasable paper / money order for income tax / blue books / Paul's cake."

Paul's cake! There was—to change centuries—the dearest freshness deep down things. And when we flung down our burdens and opened our books, sure, I saw, instead of "The Picture of Little TC in a Prospect of Flowers," the angular cheekbones of tough T.S. Paul watched, benignly, and ate his cake.

If we gave Donne's elegies (except the one on going to bed) short shrift, we learned the other poems by heart, the three of us, one of us always reading aloud, the others penciling helpful information in our margins: "Similarities of Bermudas to Heaven," scrawled this love-sick housewife, or "Soul teaches the body *bad* things." Could that be true? At home at night in the tenement that Richard and I managed, I thought about it. One evening, when, for another class, I read *Doctor Faustus,* someone banged on the door: a tenant stood—I couldn't recognize who it was because her forehead's skin had been ripped open from her hairline to her eyes and lay in a pink, seeping flap down over her nose and mouth. A jealous lover down at the adjacent Rodeo Bar had followed her to the ladies' room, waited for her to exit, then bopped her with the wide end of his crutch. The *emotions,* okay? The ongoing debate between the body and the soul.

We didn't know the elegies because we read the other stuff. We were obsessed with emotional alchemy, that pure ability to turn dull life into pure gold. Whatever it was that inspired Lord Herbert of Cherbury to write a poem to his *watch* when

he had insomnia, or Richard Lovelace who could make so much out of his girlfriend's coiffure: *"Amarantha* sweet and faire / Ah brade no more that shining haire!" Or William Cartwright, who so gallantly addressed an older woman who loved him, reminding her gently that "there are two births, the one when Light / First strikes the new awak'ned sense; / the Other when two Souls unite. . . . "

There was nothing that could not be solved, that had not already been solved. It only took thick grass, yellow blossoms, spring sun, a trick of the mind, a flourish of the pen. "I wonder, by my troth, what thou and I / Did, till we lov'd? were we not weaned till then / But suck'd on Countrey pleasures childishly?" Paul, our third, our decorous chaperon, reminded us that "countrey" in this case, meant nothing rural, but had to do with "cunts"—all those people we'd slept with who held no enchantments for us. (Sometime after Christmas vacation, I'd seen Tom Sturak in the student store, and blistering with self-consciousness, asked him if he'd had a pleasant holiday. "I slept with a girl," he'd said, smiling, teasing. He'd spent the night, he admitted finally—after scaring me out of what was left of my wits—with his three-year-old daughter, over at his mom's house.)

"For Godsake hold your tongue, and let me love / Or chide my palsie or my gout, my five grey haires. . . . " We loved to hear Professor Swedenberg recite this one in our morning class, which seemed, that spring, to be the very essence of morning everywhere, because of his sweet and florid face, his heavy southern accent, the very way he *walked,* kicking imaginary shit out of an imaginary country road. No matter who you were (and wasn't Swedenberg himself a perfect example?), or what you were, or what junk you had already accumulated in your life, didn't you have the right, the obligation, even, to be what you could, to love when you could? When you loved, didn't that carry its own obligation?

Two worlds again. Another kind of debate. At home, downtown, in the Sentous apartments, a Native American Indian lady came to the door and paid her rent with a ten-dollar bill,

wet with new blood. Another time she paid with a plastic salad bowl—translucent, with formerly alive butterflies embedded forever in it. Roaches fell routinely from the ceiling into our salads, into our guests' wine. My daughter's first living memory, she says now, is of a huge roach crawling jauntily along the ribs of her crib. A tenant who smoked in bed required us to send for the fire department *three times* that spring; irate firemen trotting down the hall with his smoking mattress speared by huge barbeque forks. The firemen laid down the law. We'd have to get rid of that sleeping smoker, they said; evict him, or next time they'd let the whole damn place go up in flames.

Another time, on the third floor, a man ice-pick-murdered the freezer unit of his own refrigerator, in a rage because we hadn't defrosted from the main unit: in came the fire department again, blowing out poison gas. Out went that tenant, and the very next week he shot someone to death in a neighboring bar. On another occasion, up on the third story, answering complaints from angry tenants, my beleaguered husband left his aboriginal-language notes, only to find that another tenant named Marklin Englefreid had *had* it: she'd put her head in the gas oven, and blown out the pilot. The other tenants deeply resented the danger to their own lives.

"Why don't you do something, do something, *do* something?" I raved at Richard, but he walked the halls, agonizing. Wasn't it her life, and hers to end if she chose? And never in a million years would it have occurred to *me* to go in.

I got pregnant, but I already knew my life with Richard was over. I embezzled five hundred dollars from the rent money and gave it to a man in the drugstore at the corner of Hollywood and Vine, who promised to take it upstairs to the abortionist and return for me. I waited there about three hours. Richard said later, "Don't worry, we'll pay it back some way." Six weeks later, in the highest balcony of some theater, watching Andrés Segovia pluck his guitar, I felt the stickiness of miscarriage. There went my electric blue dress.

"Busie old foole, unruly Sunne / Why dost thou thus /

through windows, and through curtaines call on us?" But during the Easter vacation, as the California sun almost always does, it pulled a sulky curtain. The week was drenched in clouds so thick you licked them from your lips, dashed them from your sweater. Nursery school was still in session; Richard and I planned to use the five full days without classes studying on campus. On the first morning we walked together to the Anthro building. I went on alone to Humanities and there saw Tom Sturak. "Why did you come?" he said. "Nobody's here."

We drove in his old four-hole Buick down Sunset Boulevard to Will Rogers Park, unfolded a blanket on the wet grass. Sometime during that cloudy week we kissed, but only that. Because, Tom reminded me, "No where / Lives a woman true, and faire." "True," then, in body, I fell that much more in love. Didn't the literature recommend it? And wouldn't a half-wit be able to distinguish the difference between (1) reclining in fragrant rye grass, knee-high and just going to seed; reading, listening, smiling, feeling the "good morrow to our waking soules / Which watch not one another out of feare; / For love, all love of other sights controules" and (2) figuring out how to collect the rent from the crazy man and his three children who hadn't paid in *eleven months*? Or how to get the convict's wife (who, mourning in a closed room for her jailed husband, stashed her used sanitary napkins under her bed) to clean her apartment?

Infidelity and/or romantic love would be an ongoing theme in our graduate school years. After Tom and I were together, we gave a party. A married friend of mine came, saw a bachelor who looked like Jean-Paul Belmondo (or, as if he'd had silicone lip-implants), disappeared into our mildewed shower with him. When, hours later, she came out, three lives would be irrevocably changed. Science might have given us something else to think about, if only the pursuit of jobs which might eventually pay us a living wage. But all of us were anchored by the Humanities, in muddy depths where all we could afford was adultery and/or romantic love, the intoxications of deed and word. Even that always affable Sidney Rich-

man, friend of Tom Sturak, would eventually leave his wife
(temporarily), for a leggy blonde, a "Goldwater Girl."

That spring, at school, we lived in love, as we began, preoccupied, to gear up for our First Qualifyings. We suffered severe
recurring bouts of panic: out in the grass, reading Milton's
"Comus," we simply couldn't figure it out. What *about* those
pigs? Once the fog was so thick we couldn't go out in the grass
at all. At home, the constantly complaining tenants reminded
my husband and me that maybe the roaches wouldn't be so all-
fired *thick* if we could bring ourselves to call up the exterminator, but we were too busy studying.

Blitz. "Mythomystes" sent us over the bridge into brute
hysteria. Sitting on a fog-damp bench on the shady side of
Royce Hall, Paul Frizler tried to make sense out of it: which
came first, Michael Drayton's "Epistle to Henry Reynolds"—
"But soft, in sporting with childish iest / I from my subject
haue too long digrest"—or Henry Reynolds's "Mythomystes,"
which began—read to us in Paul's halting, velvet voice (his
mother thought he was out of his mind to be spending his time
this way, his wife worked so hard to support him in this
endeavor, and what he *really* wanted to do was make movies):

> I have thought vpon the times wee liue in,
> and am forced to affirme the world is
> decrepit, and, out of its age & doating
> estate, subject to all the imperfections
> that are inseperable from that wracke and
> maime of Nature, that the young behold
> with horror, and the sufferers thereof
> lye vnder with murmur and languishment.

"Jesus Christ," Tom Sturak ranted. Do you know how
much of this there *is*? Forty pages. *Fine print!*"

> Euen the generall Soule of this great
> Creature, whereof euery one of ours is a
> seuerall peece, seemes as vpon her

deathbed and neere the time of her dissolution
to a second better estate and being; the
yeares of her strength are past, and she
is now nothing but disease, for the Soules
health is no other than meerely the knowledge
of the Truth of things: Which health the
worlds youth inioyed, and hath now exchanged
for it all the diseases of all errors,
heresies, and different sects and schismes
of opinions and vnderstandings in all matter
of Arts, Sciences, and Learnings whatsoeuer.

"I don't get it," Tom Sturak raved. "I want to know *why*?
Why do we have to read this? Why is it required for the exam?
How is any of this going to help us in any way?"

"What the fuck do *we* care?" the dozens of fake Romanesque
and tacky modern brick buildings of UCLA silently answered
us. "We are a Great University. You are the scum of the earth.
Read it and weep, suckers!"

By now we knew, really knew, that only fifty percent of us
would pass our Qualifying exams. (And women knew, in their
guts, that they'd be lucky to pull 25 percent, or ten. We were
okay to sit in class, but who would ever want a woman English
professor? You could look at women in this department, count
them up on both hands and have eight fingers left over to type
fifty words a minute.) Still, we read on, bitterly and doggedly,
to the last page:

And let our writers write, if it can bee
no better, and Rimers rime still after their
accustomed and most accepted manner,
and still capituate and rauish their like
hearers. Though in my owne inclination,
I could with much iuster alacrety then in
person of the *Roman* poet, with his *Vilia*
miretur vulgus, or *Roman* Orator, with his
Similes habent sua labra lactucas. . . .

99

It was hopeless. When I slept I had nightmares in Old English, the verb *neman* rolling past me in shimmering fog: I saw the word but couldn't know what it meant. When I woke, sweating, I read Francis Bacon's prose, which might nudge someone sitting in the electric chair into a last-minute nap. I stayed up all night when Lisa had the measles, and heard for the first time the chatter and clamor of birds at four in the morning as, down in this seared neighborhood of rat-infested tenements, they made ready to herald the dawn.

We gave up sleep almost altogether, devoting all our hours to love and study. The first time we sneaked past the landlady and I went to Tom Sturak's exceptionally clean furnished room, I looked at the books lined up on a starched runner protecting his bureau, and he gave me another ranting lecture on how in 1926 Julia Peterkin had won the Pulitzer Prize for *Scarlet Sister Mary* while Hemingway's *The Sun Also Rises* had been ignored. Talk about the perfidy of women!

Other times, in the park, he would smile at me angelically and say, "I have a terrible temper," which he did, or—of his first wife—"Ah, she's a pain inna butt," which she wasn't. Other times he would pluck fretfully at his perfectly flat, hard stomach and cry out, *"Look at that!* I'm nothing but a *garbage pit!"*, or, pinching the bridge of his nose, would rail at his Slavic features, "What a terrible thing it is, every time you look out of your eyes, to have to look at your own nose!"

During that spring, as, at home, after dinner, under harsh lights, I tried to cram in some extra Wordsworth, or remember what Mather followed what Mather, I'd look across at Richard, locked in a tightening matrix of wondering how to tell him, what to tell him. It was true, all too true, that several years before, in his anthropological studies, he had come across the information that in the tribes he most admired, the notion of romantic love did not exist. He had used this repeatedly as justification of the fact that he had never once said he loved me, the stingy emotional skinflint! On the other hand, Richard was a good guy; he had gone in, finally, and rescued Marklin Engelfried when she put her head in the oven. He worried

himself sick when Lisa was bagged out with the measles; he was as good as gold about taking his turn reading her stories.

The sad thing was, Richard was in hell himself, without even the notion of romantic love to redeem him. An anthropology professor had asked over a dozen of his "best" students but provided just one six-pack of beer. To a drinker like Richard, that was the gypsy's warning. Another professor had told some of his burlier students that he needed a lawn put in. Richard spent most of his weekends before his own qualifyings hauling wet sod. When, during this period, as I spent part of a Saturday morning vacuuming our apartment and he came in from an hour of replacing light bulbs in the hall—which our tenants promptly stole—he said, "If I *do* pass these exams and get my degree, I want us to go to the Australian outback. And I want us to stay there for at least seven years." I was too tongue-tied, too full of guilt and anguish, to say anything but "Okay."

"You can take along some *Vogue* magazines," he said. "That's what the other wives do. It won't be so bad."

The exams came in two-hour chunks: we took four of them. Eight hours of writing, and if we passed three out of four written we went in for a three-hour oral with our newly formed doctoral committee. Even at that point we could be weeded out. I wrote about Modern British and American Lit, eloquently evoking Eliot's *The Cocktail Party*. In the seventeenth-century exam I looked over at Bob Newman (maybe fifteen of the in—and out—crowd, carefully spaced, throughout the English Reading Room, taking these exams). He was so busy constructing a lined paradigm for everything that had happened in that century he barely left time to write in his blue book. I don't remember the other two subjects I wrote in, but I do remember sitting in Mr. Espey's office as he stared down at his desk and said, "There was some discussion on some of this, but all in all, well, you're going to take the orals."

Triumph, but a limited one. Since I'd had to leave one exam early to collect (second) prize in the Samuel Goldwyn Creative Writing Contest and gotten my picture taken for the *L.A.*

Times, I figured that was the only reason they'd let me squeak through. (Tom Sturak had been stopped in the hall and told he'd done the best set of writtens they'd seen in a long time. Comparatively speaking, he hadn't even studied!)

The orals were hideous torture. That man, who had once so passionately opined in a teaching assistants' meeting that you couldn't remove *one word* from a Virginia Woolf essay without changing its whole texture, emerged, elated from three hours.

"How'd you do?" I asked him enviously, already knowing that his answer would be a confident, "Good! Good!" Ten minutes later, after his committee came out, he was broken, gone, wrecked; his career, his hopes, shattered. We never saw him again.

Curiously, most of the giddy ones, the party-dolls, the scandal-makers and chasers, *the In-Crowd,* came through. Was it our natural bent for scholarship, or simply that the department could not admit that *it* had failed on such an across-the-board level?

As I stood outside Mr. Espey's office waiting to go in for my oral, Leon Howard took out a Kleenex and dabbed at my cheek. "You've got something on your face." I certainly did—a birthmark that had been there for twenty-seven years. And once inside, Paul Jorgensen, another of my examiners, began his questions by speaking to me in Old English—my worst *neman* nightmare come true. But I remembered what river was a strong brown god and where that came from, and Tom Sturak said later, "I walked by and the door was open. I heard them laughing and I saw you swinging your legs, so I knew it was okay." Espey told me I had passed on the condition that I reread ten of Shakespeare's better-known plays.

With a few exceptions, the In-Crowd could go on. We had qualified. We had our M.A.s, our first advanced degrees. Even Richard, through all his silent sorrow over in anthropology, had passed his exams. One Sunday we went househunting, down in Venice; in a month or so we might get out of that terrible Sentous apartment. But I had written a novel in that

terrible apartment, and the second prize I'd won for it would give me the money to finance a divorce. Tom Sturak and I would go to Reno that summer. When I told Richard, I cried uncontrollably; he seemed to take it with imperturbable calm. "You say you love him now," Richard said, "but everything is new. What do you think is going to happen in five years, ten years?"

"I love him," I blubbered, but Richard's belief system wouldn't allow that supposition. I went to bed soon after this conversation and Richard went back to the stack of papers he'd been correcting. By the time I took a train to Victorville, a desert town where my mother lived, to leave Lisa in her care for a weekend, so that Tom and I would have a chance to consummate this affair we'd blathered on so much about, Richard would grit through his teeth, seeing us off, "I love you." Too late.

Events followed in rapid order. Tom Sturak drove up to Victorville and incurred my mother's immediate and undying enmity because he didn't offer to mow her lawn. We drove away for three days to make love, and it was very nice—after all that suspense—though we were troubled by good manners; how, after all those "authentic tidings of invisible things," did you actually hunker down and *do* it?

On the fourth day we drove back by Victorville, on our way to Reno, to pick up Lisa. I found my mother in the backyard. Lisa saw me and burst into tears: "I *told* you she'd be coming back for me!" My mother met my eyes with level hatred (for was I not doing to Richard the very thing my father had done to her so long ago?). "How did *I* know?" she queried malevolently, and another two chunks of undying enmity fell into place.

By the end of the summer, we would have acquired four advanced degrees: three M.A.s and one divorce. One night, in Reno, I woke up, touched that blond, smooth, hard, drenched-in-Bay-Rum-and-Aqua-Velva body next to mine and felt a wave of crazy joy: this was the good-morrow of my life! Finally I was going to have some adventures, and devote my life to

literature and we would travel all over. Tom Sturak—for all that he seemed so hard-boiled—couldn't stop talking about love. He even said he thought it would be great if I wrote, went on writing, tried to write.

Eight weeks later, before school had started for the fall semester, the divorce was in place. Tom and I returned to L.A. and had one of our first very spirited arguments: we would *not* live in Venice, he announced, with the writers and the poets, but down in Manhattan Beach with the stewardesses and high waves, so that he could surf. *Surf?*

Richard, though he could not feel love, could feel its absence. House-sitting for his best friends, he burned the place down—so much like that crazy smoker we'd had to evict—and barely escaped with his life. At some level, Lisa would never trust me again, and at some level, she'd be right. And so, one morning in Manhattan Beach, in thick coastal fog, I woke to mourning, for everything I'd lost and ruined, and there wasn't anything John Donne or anybody else could do about it.

Once, as I drove my younger daughter, *Tom's* daughter, Clara, to school, she asked me, as we whipped past the beautiful Pacific down the highway, late as usual, "Why *did* you marry my dad anyway? Any fool could see you don't have anything in common."

"I don't know," I said. "He was cute."

"Cute?" she raved, just like her fiery dad. "You'd marry somebody because he was *cute?* Jesus Christ!"

As she ranted on, I wondered, how do you tell a twelve-year-old about lying back in the lush grass that grew so high it framed your vision of the sky, or that there was a time when Tom and I totally believed in our education; trusted authentic tidings of invisible things, knew that if the two of us were together we could make one little room an everywhere, knew that we would stay together to the grave, with locks of each other's hair twined in love braids around our wrists—bracelets of bright hair about the bone; that we hadn't figured, ever, that our waking souls might fall back separately into loutish slumber.

We didn't know, and I couldn't tell her, I didn't have the words, that the debate between body and soul had by-laws and fine print; that every betrayal carries its own punishment, as sure as car sales carry interest payments; that in addition to divorces, there was a suicide or two by now that could be traced directly to our education in Romantic Love. I couldn't even say, remembering those cheekbones, that blond hair and green grass and yellow blossoms and spring sun, and the woven enchantments of the metaphysical poets, that I wouldn't do it all over again.

"Yes," I said stubbornly, "I would marry someone for that."

Elders and Betters

I SAW HIM TWENTY YEARS LATER WHEN WE
had all gone on to different lives. In Westwood still, in
Jurgensen's—a gourmet grocery store about five blocks from
the university. It was maybe nine in the morning. He stood in
an intersection of aisles, dressed in a gray-blue suit and shirt
and tie, swaying on his firmly planted feet, smiling to beat the
band. At no one. I ducked behind some cans; he was between
me and the cash register and there was nothing to do but wait
it out. I couldn't say hello because I couldn't remember his
name, but there was no forgetting that carefully swirled lion's
mane of silver-blue hair. Finally, he left without buying any-
thing. At the counter they identified him. "Earl Leslie Griggs.
He comes in every morning. He's a little lonely, maybe. . . . "

The man who lectured sitting down, about Wordsworth,
Coleridge, Byron, Shelley. Well.

How little we knew, then, of our elders and betters. They
held our fates in their hands, but we didn't know how, or
why—or certainly what they wanted from us. And we were not
the only ones who wondered. Every year, that new crop of
ambitious assistant professors (usually four of them with
wives) came in from the East with their chinos and their sports
jackets; they too were laid low by questions that seemed to have
no answer, demands that allowed no fulfillment.

Some of these assistant professors had graduate students over for dinner, following in the wretched academic tradition immortalized by Virginia Woolf (among others) in *Jacob's Room*: "Now, does the lamb make the mint sauce, or mint sauce make the lamb?" asks the Don of the student next to him, and the poor student can only mutter, "I don't know, sir," deep in the ravages of pain, while the Don's wife can only helplessly reflect that, "Once begotten, how could she grow up other than cheese-paring, ambitious, with an instinctively accurate notion of the rungs of the ladder and an ant-like assiduity in pushing George Plumer ahead of her to the top of the ladder?" But, Virginia Woolf went on to query, "What was at the top of the ladder?"

Later it must have occurred to us that the assistant professors and their anxious wives were asking *us* just what we wanted to find out from *them*. When Earl Miner, a scholar in Japanese-American studies, asked Richard See and me over for dinner, what could he (Professor Miner) have been thinking of? Had he found out from my anguished whispers (because I was pathologically shy) that Richard was Eurasian, and might be useful to his own studies? Was it just a good deed on the professor's part? The Miner house was spotless, mostly white, with ruffled curtains in the kitchen. But the living room chairs were canvas slipped over bent iron bars; they sold at eight bucks a clip and were the very emblem of all that was ephemeral—poor, pure, and stoic—in academic life. Richard drank gallons, ended up in the living room on his knees in front of Mrs. Miner, laughing insanely, and I wept with shame in the car going home. But Mrs. Miner (with her anxious eyes) had made the finest profiteroles with bitter chocolate sauce I ever tasted, and who knows, now? Maybe she almost *liked* the idea, the sensation, even, of a softly bearded Eurasian nuzzling at her knees.

Another dinner at another assistant professor's: Richard and I arrived exactly on time, to find the harried faculty housewife, dressed in gray with bright red pumps, vacuuming the living room rug. Her husband, Jonathan, was the son of the poet

John Peale Bishop, who had been a friend of F. Scott Fitz-
gerald's. His wife, Alison, had the engaging *trompe l'oeil* effect
of a lovely face whose sides didn't quite match. I liked that,
since I had a map of North and South America on my right
cheek that I was always fiddling with—covering it up or leav-
ing it alone. Alison, I believe, liked Richard, and he liked her.
Jonathan laughed a lot and asked us frankly, what was this
hell pit they had come to from the East? How could a couple
live here? What *was* this California? And, more than anything,
what was the secret to getting tenure? How could they manage
to stay?

Money was in all our thoughts, always. That night we ate
tasty, thrifty tongue and potato salad. (Twenty years later, on
my way through Ithaca, that's the meal they served as tenured
professors at Cornell.) But no one on earth was as generous
with friendship as Alison. Seeing our poverty, she gave me
nightgowns (that sent Richard into frenzies of lust) and
blouses; she made me (without my ever asking) a brand-new
purple cotton dress. When I left Richard I spent several tense,
heartbroken nights at their house and Jonathan cheerfully
woke me up with the icky daily breakfast he made for their
three boys—"blue egg."

The Bishops always said they wanted to know how to stay at
UCLA. They worked hard for it, but something in them
rebelled. Out at dinner parties with *his* elders and betters,
Jonathan unbuckled his wristwatch and laid it out parallel to
his dessert spoon—a pretty certain hint that he wanted to be
somewhere else. On another occasion, Alison phoned me, fran-
tic and strung out: "It's a Sunday afternoon, right? And so no
one should be around. So I took the kids and went to return
some books to the English Reading Room. But the whole
faculty was there! With *pearls and tweeds and teacups!* And
what did I have on? A pair of leotards and a maternity smock
and nothing else!"

"*Oh, God, oh God, oh God,*" as Virginia Woolf's Jacob ex-
claimed when he escaped from the Don's lamb luncheon, "*Oh,
my God!*" The sadder, creepier truth was, whatever academic

sins Jonathan committed, Alison's transgression was her mere physical presence: "Oh, Alison, please don't walk down the hall again!" was the title of Bob Newman's disgruntled graduate-student poem about her. The feeling was: faculty wives should stay home, tending their clean and modest houses, perfecting their bitter chocolate sauce.

And still the untenured wanted to know our secrets. By the time I was married to Tom Sturak, and we were all working on our dissertations, an ambitious assistant professor made callous by stress, asked me, "How'd *your* husband ever get in here? He's a friend of Leon Howard, that's the only reason, isn't it? He couldn't have done it any other way."

"Well," I could have answered, "he *might* be smart," but, in truth, by that time, I was beginning to have my own doubts.

After those first harrowing Qualifying exams, if we were allowed to go on, we decided on three specialties, developed a ready fluency in a second foreign language, chose our dissertation topic, took a deep breath, and looked around. This was a Great University. Even as undergraduates we had been told we were "among the top five percent." Now we had to be something like .001 percent. (Of *what,* we might have asked, even as Mr. Espey's wife, at another whole dinner party, in a totally other time and place, sitting next to a red-faced bore who told her he kept "fit," snapped back, "Fit for *what?*")

Daily we dressed neatly and went to advanced classes, learning. Vinton Dearing, eighteenth-century scholar with a soul and demeanor as sweet and clean as a polished pewter platter, sang snatches to us from Dinah Shore songs. "Did you see Dinah last night?" he'd ask us. He loved Dinah. Another time he read a passage from a diary (it may have been Samuel Pepys or John Evelyn) as the writer went to check out a particular eighteenth-century female entertainer in tights. She was some babe, the writer recorded, "except I perceive she has bends in her haunches. . . . " Dearing beamed. The class blinked.

How *hard* is teaching, and what does it, *teaching,* even

mean? On a cold gray morning in a high-ceilinged hall, Professor Alfred Longueil labored with a hundred resentful students over the Middle English cadences of Chaucer's "Parliament of Fowls." Longueil was a perfect gentleman and professional. Agnes de Mille, who went on to be famous in modern dance, had fallen in love with him when she was a student, but her/his conscience was clear on that point. He was so dedicated—the story went—that he taught his classes even on the day after his wife died. He always wore one of three versions of the exact same suit and always looked courtly and wonderful. His patience was legendary, but on this particular gray morning, even he cracked. He looked up, in the midst of this chronicle of eagles and crows and sparrows and so on, and bitterly remarked, "You don't even think it's funny, do you? *None* of you sees the jokes." Two hundred eyes looked up in dismay. The "Parliament of Fowls" was the saddest thing we'd ever read, and—outside of "Mythomistes"—the most useless.

When Will Matthews—that self-made king of Old English—handed out three pages, self-typed, explaining the Great Vowel Shift, he had saved paper by typing *half*-space. The blurred and inky papers presented themselves to us as an impenetrable maze of squiggles, utterly and absolutely unreadable. When Blake Nevius taught us about American literature, he had a bad fever for the whole semester. You hated to ask the poor man a question, he felt so lousy. And there were separate schools of thought within the department. A professor who did not hold our views was rumored to hold all, *everyone,* in contempt. He had written a book no one could read, and thought he was smarter than the rest. We, the In-Crowd, never took his classes. Only our enemies took his classes. When one of his disciples called up fifteen years later to ask if we were okay during a brush fire that raged around our canyon home, we took a long-term revenge: "So," the then-man of the house asked somewhat drunkenly, as smoke choked us, and the cars, loaded with our worldly goods, stood ready for evacuation, "Are you still writing that derivative poetry?" She retaliated by attacking us in her first annual Christmas newsletter, and

sending us a copy. Such rancor! Over an allegiance to—a preference, merely, for—a long-lost professor! *Why?*

The In-Crowd first cast our lot with Leon Howard (his high-calorie dinners, his Coat-Hanger Theory of American Literature, and his raucous Southern accent which allowed him to call that famous Poe story *The Poiloined Lettuh*). We felt honored to be in the same room with Jimmy Phillips, who made the already perfect Shakespeare more perfect. Professor Phillips called things he didn't like "sick-making," and eventually married one of his students, a woman as lovely in face and body as she was in soul, which was saying a lot. And our three-hour modern poetry seminar each Tuesday with John Espey was gold, as he wheezed and joked and poked his eyeballs with the prongs of his glasses and quoted the classics the way Ezra Pound liked them. (In "Homage to Sextus Propertius," writing "We played together with our shirts off. . . . ") "You can imagine," Espey remarked, "what the editor of *Poetry Magazine* thought about *that*. . . . "

Perhaps because the word *dichotomy* came up so often in our papers and in the first drafts of our dissertations, we began to find ourselves in Second-Thought City. We would *die* to be Jimmy Phillips or John Espey, but what if we turned out like . . . well, we were too polite to say *who*, but those thoughts stayed with us as we struggled and plodded through our *second* foreign language, working an hour at one paragraph, only to find out at the end that the German or Italian in question had been saying something stupid all along.

Scholarly Stan Stewart began to have second thoughts about his dissertation on "The Enclosed Garden," and came into the office one afternoon, flushed and tempted. "You know what they're paying at the RAND Corporation for someone who can read and write? Eight thousand dollars a year!" Crazy Charles Culotta had no end of trouble with his annotated edition of Christopher Harvey's "The Synagogue." Shy Tom Mauch would end up writing his monumental work on sixteenth-

century proverbs *three separate times,* suffering torment that
cannot be described, though he put a brave face on it, remind-
ing us continually that Thomas More, when he went to the
privy, couldn't decipher the renaissance graffiti, "A D.C. hath
no P." More had to ask around to find out that it meant "A
drunken cunt hath no porter." By himself, More figured out
"Short and thick doth it quick," a proverb that my father was
able to confirm still existed four hundred years later in central
Texas. But what was one to do with all this . . . shit? Mauch
proved conclusively that "the world is as round as a ball" was
the world's dumbest proverb, but so what? No wonder that his
falsely smiling dissertation director made him rewrite his
hundreds of pages those three separate times. Mauch would
console himself, as Doug Scott (having already quit school to
work for the RAND Corporation, on his way soon to be a
translator and consultant in Vietnam) lifted a cup of coffee
and, in a fit of social anxiety, poured out the whole thing on
his chest. "Many a slip," Mauch mumbled pertinently, "twixt
the cup and the lip." And when our parties—still dazzling
events in our eyes—took us to a lovelier, rosier world, Mauch
would remember to remark, " 'Tis merry when knaves meet."
When he was feeling cynical he might observe, "Nab me and
I'll nab thee," going on to remind us that to "nab" was to take
the back of the neck gently by the teeth and carry someone/
something away, thus the word "nab" was to steal, *as if we
didn't know all that by then!*

Some of us, by then, had begun to slip away. When Tough
Tom Sturak and I went to live for a year in Mexico, Judy
Wilson Hurst quit school, lamenting that "there was no one
left to have coffee with." Bonnie Culotta went off to teach.
Doug Scott, his eye always on that Larger World, was happy
when RAND sent him to Vietnam. Paul Frizler and Sheri went
dancing one night at the Cheetah, a new discothèque by the
Santa Monica Pier. When they came out his dissertation (on
Victorian pornography?) had been stolen from the back seat.
Two real and genuine writers (not lowly students like us) had
been beaten away from the program. For years, Irving Shul-

man, whose *Amboy Dukes* had been a classic of the forties, couldn't please his committee; there were rumors that he'd had to employ a ghostwriter to obtain his degree. Robert Kirsch, novelist and book critic of the *Los Angeles Times,* found that his dissertation couldn't slip on to Leon Howard's Coat-hanger Theory of American Literature. Kirsch would finally obtain *his* degree from a "lesser" institution. We were all pushing thirty and still poor as K-Mart. These were days of anxiety and gloom. The Cuban Missile Crisis had come and gone: we were going to have to live through this. We couldn't expect World War III to get us off the hook.

Two years before, newly "together," Tom Sturak and I had signed up for Leon Howard's advanced seminar in American Literature. The drill: each one of our papers, by the end of the seminar, would become a chapter in each one of our disserta-tions. We could see, three years away, the end of our seven-year graduate-student tour. That first day, apprehensive and com-petitive, we took turns around the table talking about our papers; our dissertations. Tom spoke up about Horace McCoy, a Hardboiled Writer who had written five novels, gone Holly-wood, devoted himself to the movies, then died. Leon Howard thought that was okay. I suggested a dissertation on Nathanael West, who had written four novels, gone Hollywood, devoted himself to the movies, then died. Leon Howard asked, "Aren't you just doing that, Carolyn, because *Tom* is doing the same thing?"

I went home that night, outlined a doctoral dissertation that would encompass every Hollywood novel ever written, and in which Horace McCoy showed up as just a flyspeck. I went to John Espey, asked if he would chair my dissertation, and didn't speak another direct word to Leon Howard for at least twenty years.

It was as if Mr. Coat-hanger Theory of American Litera-ture's thoughtless jibe had opened a long-festering wound. Under all the smiles in our old photographs was rage to burn, and contempt. How dare they! I mean, *how dare they!* Only two women at that time on the permanent English faculty, and

look how those smug white boys brought in the lady English undergraduates, strung them along to fill their classes, then flunked them out, then wouldn't hire them, then condescended, then . . . how *dare* they! These dark thoughts, once I allowed myself to have them, spilled over to Tom. When we went to Mexico to study for a year, he went skin diving every day; he didn't have to worry, he was a golden boy in the department. I read a novel every day and downed a six-pack, and didn't care to listen anymore to his talks about existentialism.

When we came home, I wrote like a demon, but in secret. No one was to know how hard I was trying. At our parties, people got drunk, fell down, despaired. My dissertation anxiety was such that I once broke out in a sweat while I stood under a shower.

The day I defended my dissertation it went easily and well. John Espey, seeing me afterward standing alone in the hall of the Humanities Building, asked me what I had planned for the rest of the afternoon. When I said *nothing,* he half-heartedly asked me to lunch. It was a forlorn meal. We had nothing to say to each other. Afterward, back on campus and terribly sad, I walked down to Veteran's Housing where Judy Wilson Hurst was now Albaum. Her husband was in Law School. She saw him from time to time, she said, mostly when he pinched her while she stood at the sink doing dishes. We watched the fish in her aquarium. "There's nothing left for me to do in this world," she said. When I went home neither my (visiting) mother nor Tom said anything to me. "I passed the exam," I told them. "I'm a Ph.D. *Doctor* See to you!" Then I wept, bitterly. Tom and I went out to dinner. He had at least two years to go for his degree. I'd seen to it, by writing fast, and secretly, and hard.

And home then, to more weeping, and bad years. Espey had gotten me a two-year appointment as instructor, making real money, waiting for Tom to finish, so that our lives could "begin." But one set of good times (for me, *just* me, maybe), the second best years I ever had in my life, were irrevocably over.

∎

Looking back, you can see so easily that what we wanted from our Great University, from our august professors, was not at all in their power to give. As fine as their motives were, they were working—then—off that white Protestant, white male, hierarchy, which had more to do with the Marines than learning. There *was* a ladder, that same one Virginia Woolf talked about in *Jacob's Room*, but some of us were not supposed to climb it. We were just supposed to hold it steady; to offer our clasped hands as footholds for the others. Again, in a slightly revised form from what we'd thought we'd known about it, taking it from the top and going down, the hierarchy went: male faculty, male students, female faculty, female students, faculty wives, children, custodians, gardeners, dogs. But in the sixties, the hierarchy was just beginning to fall apart.

Alison, the wife of Jonathan Bishop, that wife who could not refrain from walking the halls of this masculine keep, found a job typing for a professor. This wing of the Humanities Building was five stories high. Each key opened five offices, she told me, offices vertical to each other. Alison, they say, one day opened the wrong office door and observed its occupant screwing his brains out with an unidentified female on top of his desk. So great was Alison's fear (since, if the professor saw her, *her* husband would not get tenure) that she threw her maternity smock over her head, pointed to her stomach, and said, "Watch out! Or else *this* could happen to you!" (And, with all that, or without it, her husband did not get tenure.)

Nothing was what it seemed. Leon Howard, at the end of one of his student parties, gave me a big french kiss. As I stood there, half-drunk and very depressed, he summed up his position in one sentence: "Don't worry about it, Carolyn. None of it means anything." He was having his own trouble; his beautiful daughter had married a philosophy professor, Hans Meyerhoff, a man close to his own age, who lectured brilliantly on existentialism to packed houses. Our heritage did not necessarily mean we had to suffer, Meyerhoff opined. It was within our power to, by changing our patterns of thought, change our

destinies. One day, as Meyerhoff stopped at an intersection on Sunset Boulevard close to the university, a car rammed him straight off this planet. The baby was thrown clear.

Another day, as John Espey moped in his office, a shy girl, who, he later said, "looked about twelve," poked her head with its gamine haircut in his door. She was a faculty wife, she said, she'd written something, could Espey look at it? Later, at a reception, a bumptious assistant dean of something thanked Espey for "helping my wife with her little hobby." But Espey, reading, saw something else, and Dinny, quiet wife with four children, became critically acclaimed novelist Diane Johnson, and full professor, and movie writer, and world-traveler with a new husband, and applause, and a new life. Of that first assistant dean nothing much is known.

Dinny had already befriended Alison, who also wrote in her spare time. Alison, to everyone's bemusement, kept up her old acquaintanceships in the East, as she cooked dinner after dinner to advance her husband's career, offending members of the academic Old Guard when she wrote, innocently, on invitations, "Meet Your Friends at Jonathan and Alison's," since how could she have the effrontery to think that any of *their* friends would come to *her* party, and so on. She worked under such a sense of stress then, that once she came to a faculty pool-party having shaved just one leg. When Jonathan didn't get tenure, she went ahead and published a novel about the English department at UCLA, and its connection with the RAND Corporation (using her maiden name), to everyone's blown-out sense of outrage and ruffled-feather disgust, because although she never really said anything *mean* about the department, she just didn't take it seriously; she seemed to see through it to another vision that embodied a more real "California." Alison Lurie went on to write another and another and another novel, and won the Pulitzer Prize, and became a full professor at Cornell, living companionably down the hall from her (ex-)husband.

In the winter of 1961-62, the Great Bel Air Fire came, a brush fire usually reserved for wilderness sticks of places like

Topanga or Malibu, raging now in mansions above Sunset, close, close, to the university. It couldn't be happening, because such things didn't happen. The professors went on teaching, and thought little of it. Leon Howard's family stayed at home, closed the windows, wet down the roof, beat out sparks with rugs. That house was saved, though many around it burned to ashes. Will Matthews, that expert of Old English—the way we heard the story—took a phone call from his wife, heard from her about the fire, and went to teach a class. When he'd finished his customary hour of bone-lockers, comitatus and the like, coming out of class into the by-now tainted air, he was homeless, his whole material life gone up in smoke. For the next few days professors and students filled their cars with shoeboxes of cards on Australian language, or Tagalog, or Tui, or the works of Dickens or all that stuff on enclosed gardens. Even housed in foot-thick stucco at the Johnson house, Tom Mauch prudently packed his proverbs into his V.W. well, as the fire raged just a mile or two away.

A world filled with disaster. That doomsday columnist a few years back had been at least partly right. Private worlds ended right and left. Tom Sturak still worked down at the RAND Corporation, where, Death Descending or not, he found the ladies mighty cute. And, if this does not seem to pertain to a history of UCLA, I say, why *not?* I say, if you are in the UCLA Medical Center, even now, in the surgical waiting room, you can see, on the wall, a large and tasteless portrait of all the men who invented the Medical Center, and a sad white lot they are. But underneath, suffering, hoping, living, in uncomfortable chairs, you see the people who *are* the Medical Center. And if the Humanities Building—back in the late fifties just a few years old—is now called Rolfe Hall, I dare to say, *now,* that we stayed away from Mr. Rolfe—though we knew his accomplishments—and what is now Rolfe Hall might be far better named Mauch/Stewart/Newman/Sturak/Frizler/ Hurst-Wilson-Albaum/ Lurie/Johnson, and yes, See, Hall.

Only two women in the department in those old days, but they went on and worked, and became pioneers of learning at

that school, as unexpectedly as those faculty wives who had the effrontery to get famous. And the money poured in to make UCLA bigger and bigger and bigger, so that it groaned and lurched and finally *flew,* and where, even in my memory, its main competition had been with its sister university up in Berkeley, now it routinely finds itself in the top ten or five in the United States in one category or another, beating out brick Harvard or stone Yale.

I stayed home for a while with my new baby (having missed, however, only one class of teaching), taking my end-of-the-class applause as an end-of-pregnancy-celebration. Alone, then, I read Betty Friedan, thinking, "Wow! Now I get it! I sure wish I'd read this back when it counted, instead of 'Mytho-mistes'!" I was home when Tough Tom Sturak, over at the RAND Corporation, found those other ladies, and there was no Alison Lurie there to pull her maternity smock over her head and shout, "Watch out!"

And because public and private lives overlap and no one knows where the "issues" of the day become our lives, Doug Scott had his heart broken and his ideals crunched in the Larger World of Vietnam. Tom Sturak worked for the war at RAND, though he stoutly maintained he was "boring from within." Stan Stewart, Sidney Richman, Bob Newman, taught. Tom Mauch married, but early misfortune made his marriage starcrossed. He went on to translate Boccaccio. One very nice guy in the In-Crowd left his wife and went off to live in a trail-er with another nice guy. Charles Culotta broke up with Bon-nie, married a girl named Wendy, left her three days later, came back to her and left her and so on for twenty-five years. Paul Frizler taught classes on film and produced charming musicals about rock 'n' roll. Judy Hurst Wilson Albaum ended up with one last married name, traveled the world, and lived for a while on the island of Yap, swimming in water so clear and life-filled that little fish swam into the pockets of the shirt she wore to protect her white shoulders from the sub-equatorial sun. By the time she turned fifty she was back, working again in a sub-division of the UCLA Medical Center, sometimes with Nor-

man Cousins about the effect of laughter on sickness, some-
times in medical forensic law, and finally on a joint project
with the RAND Corporation that might do something *good*
for a change—an analysis on how much the AIDS epidemic
will cost the United States, and who's going to pay for it. (So,
see? Judy was wrong when she watched her goldfish in Vets
Housing. There was lots more for her to do in the world.)

Everyone ended up being true to his or her school. Tough
Tom Sturak, in one of the great good deeds of his life, took his
cute editorial assistant from RAND over to UCLA, to show her
where he had passed his second youth, his better adolescence—
to recount to her how he had avoided adulthood in his twenties
and even on past the grim three-oh. He sat with her on a
concrete bulkhead in the inside courtyard of what was by now
Rolfe Hall. To his left, in this benevolent U-shaped building—
a little crumbly even after only fifteen years—the classrooms
where he and all his friends had learned to teach. In front of
him, the English office, where we all once had our own boxes,
where he had sometimes left valentines and notes and a book
on the metaphysical poets for the woman who was now his
second, unloved, wife. To his right, the cubicles where he had
drunk Tang to stimulate his brain cells, with his buddies in the
basement. Just above that, the offices of the academic Old
Guard, whose teachings had changed his life.

"I looked out of my window," John Espey remembered,
"and I saw Tom and Carolyn right outside. I decided to go out
and say hello. Of course, when I got a little closer, I realized it
wasn't Carolyn at all." In an act of speculative gallantry, Tom
Sturak had made a kind of living will. Our marriage would go
on about four more years, and John Espey was married, very
happily. Still, Espey would remember, and after our divorce,
and after Mrs. Espey's death, there came a sunny Southern
California day when the chairman of my doctoral committee
came to visit his old student in Topanga, and sixteen years
after *that* I can say what I finally did learn from UCLA; to live
in kindness and stability and love and fun.

A lot of other stories come out of those five square miles of

red brick buildings. All the sociology ones, the art ones, the football ones, the medical center ones, but ours are *ours,* and we still tell them. A month ago Doug Scott, successful playwright now, came into town, and Tom Mauch, to teach a learned seminar at USC. We met, along with Mr. Espey, at Ivy-at-the-Shore, a seaside restaurant just a stone's throw from the Pacific, a block from that big old RAND Corporation. "Do you remember," Doug asked, fifty by now, "when we were all supposed to meet over on the East Side to listen to Mexican music at Third and Evergreen and when I got over there I found out those streets didn't even *intersect?*" Of course we remembered. Who among us could not recite Doug's poem of complaint that began, "Tom, Tom and Caroline. . . . "

And, as Espey's eyes glazed over (these weren't *his* stories), we ate crab cakes and drank champagne and remembered Doug's other verses written in our first silly Golden Days: "What if the crystal you / Devoured the Christmas me / An equinox of rendezvous / Decries our merest mummery. . . . " We saw, looking at dearest John Espey, that our professors would be forever young. We knew—through the power of friendship and the beneficence of a Great University—that enough was as good as a feast but a feast was even better; it would always, always be merry when knaves meet.

ABOUT THE AUTHORS

CAROLYN SEE is Professor of English at UCLA. Her book reviews appear regularly in the *Los Angeles Times,* she is a member of the board of directors of the National Book Critics Circle, and she is president of PEN Center USA West. She is the author of five novels, including *Making History,* which will be published in fall 1991 by Houghton Mifflin Company.

JOHN ESPEY is Professor Emeritus at UCLA. He is the author of a book on Ezra Pound and the co-editor of a book on the decorative book bindings of Margaret Armstrong. He has also written three novels, as well as four memoirs of his youth in Shanghai, including *Strong Drink, Strong Language,* published in fall 1990 by John Daniel and Company.